Auguste

Renoir

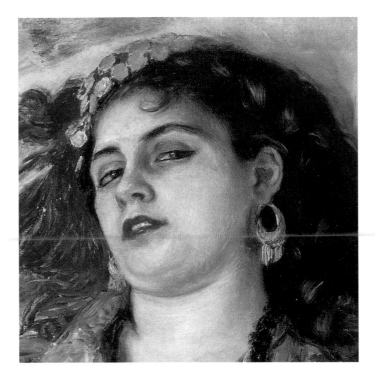

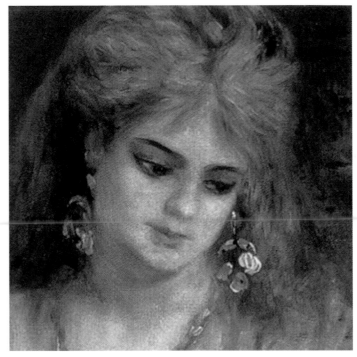

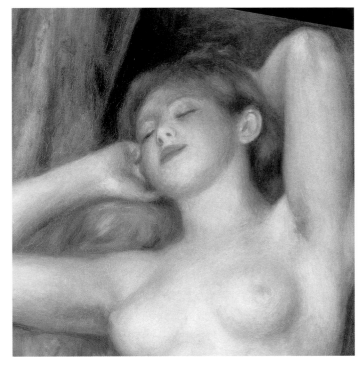

Cover: Stéphanie Angoh
Page layout: Julien Depaulis

© Confidential Concepts, worldwide, USA, 2003
© Sirocco, London, 2003 (English version)

Published in 2003 by Grange Books
an imprint of Grange Books Plc
The Grange Kingsnorth Industrial Estate
Hoo, nr Rochester Kent ME3 9ND
www.Grangebooks.co.uk
ISBN 1-84013-559-X

Auguste

Renoir

Grange
BOOKS

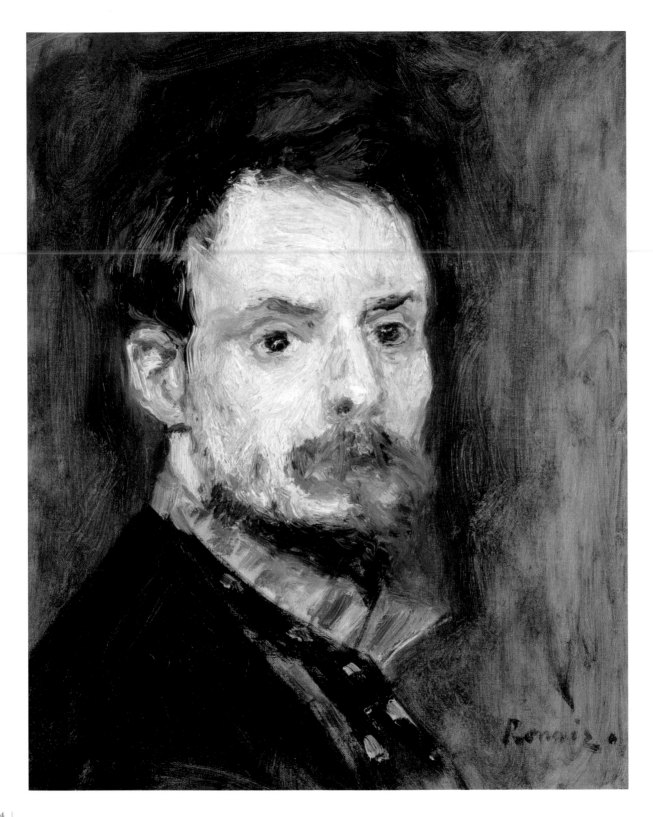

Pierre-Auguste Renoir was born in Limoges on 25 February 1841. He was the sixth child in the family of Léonard Renoir and Marguerite Merlet. Three years later, in 1844, the Renoirs moved to Paris. In 1848, Auguste began attending a school run by the Frères des Ecoles Chrétiennes. Renoir was lucky with the music teacher — it proved to be the composer Charles Gounod, who took the boy into the choir at the church of Saint-Eustache.

In 1854, the boy's parents took him from school and found a place for him in the Lévy brothers' workshop, where he was to learn to paint porcelain. Renoir's younger brother Edmond had this to say:

"From what he drew in charcoal on the walls, they concluded that he had the ability for an artist's profession (...)The young apprentice set about mastering the craft seriously: at the end of the day, he armed himself with a piece of cardboard bigger than himself and headed for the free drawing courses. It went on like that for two or three years."

He made rapid progress: a few months into his apprenticeship, he was already being set to paint pieces that they usually gave to qualified workers. That made him the butt of jokes. They called him Monsieur Rubens and he cried because they were laughing at him. One of the Lévys' workers, Emile Laporte, painted in oils in his spare time. He suggested Renoir make use of his canvases and paints. This offer resulted in the appearance of the first painting by the future Impressionist. It was solemnly presented for Laporte's inspection at the Renoir's home.

Edmond Renoir recollected: "It's as if it happened yesterday. I was still a boy, but I understood perfectly that something serious was taking place: the easel with the celebrated painting on it was set up in the middle of the largest room in our modest dwelling on the Rue d'Argenteuil. Everyone was nervous and burning with impatience. I was dressed up nicely and told to behave myself. It was very grand. The 'maître' arrived... At a signal, I moved his chair up close to the easel. He sat down and set about examining the 'work'. I can see it now — it was *Eve*. Behind her, the snake was twined around the branches of an oak. It was approaching with open jaws, as if it wanted to cast a spell over Eve.

1. *Self-Portrait*, ca. 1875,
 Oil on canvas,
 36.1 x 31.7 cm,
 Williamstown (MA),
 Sterling and Francine
 Clark Art Institute

The trial lasted a quarter of an hour at least, after which, without any superfluous comments, that poor old man came up to our parents and told them: 'You should let your son go in for painting. In our trade the most he will achieve is to make twelve or fifteen francs a day. I predict a brilliant future for him in art. Do all you can for him.[1]" That is how family legend recorded the birth of Renoir, the artist.

Auguste Renoir positively acknowledged the role his family had played in shaping his future. It was from his parents that he obtained the respect for the crafts which remained with him all his life. Renoir liked the fact that his father and mother were simple people:
"When I think that I might have been born to intellectuals! I would have needed years to divest myself of all their ideas and to see things as they really are, and in that event I would not have had enough dexterity in my hands [2]."

Besides the family, however, there was one other major educator in Renoir's life — Paris. In his conversations with his son Jean, the artist constantly recollected those little corners of the capital where he had spent his childhood and youth, many of which had disappeared before his eyes. One might see the hand of fate in the fact that after moving from Limoges, Léonard Renoir installed his family in the Louvre. The houses constructed in the sixteenth century between the Louvre palace and the Tuileries for noble members of the royal guard had by the middle of the nineteenth century lost their former imposing appearance. Only remnants of the old decoration — coats-of-arms, capitals, empty niches that once held statues — served as reminders of the past. Now occupied by lower class Parisians, this little district had a special atmosphere about it, oddly combining the everyday and the elevated. The Renoirs lived on the Rue d'Argenteuil, which ran through the whole area down to the Seine. Here, in the courtyard of the Louvre, the little Renoir played with other boys.

It was entirely natural to go inside the palace which had become a museum at the time of the French Revolution. "When I was a boy, I often went into the galleries of ancient sculpture, without even knowing precisely why. Perhaps because I passed through the courtyards of the Louvre every day, because it was easy to get into those halls, and because there was never anyone there. I stayed there for hours, lost in day-dreams," Renoir told the artist Albert André [3].

The young Renoir's wanderings covered a far wider area than the Louvre district.

2. *Jules Le Cœur Walking in the Fontainebleau Forest with his Dogs*, 1866, Museu de Arte de São Paulo, São Paulo

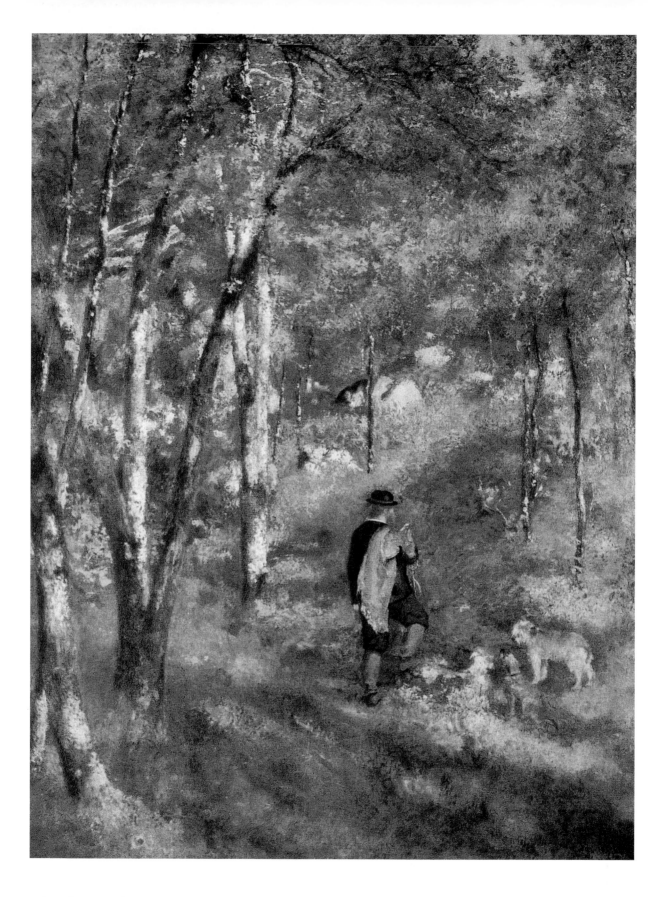

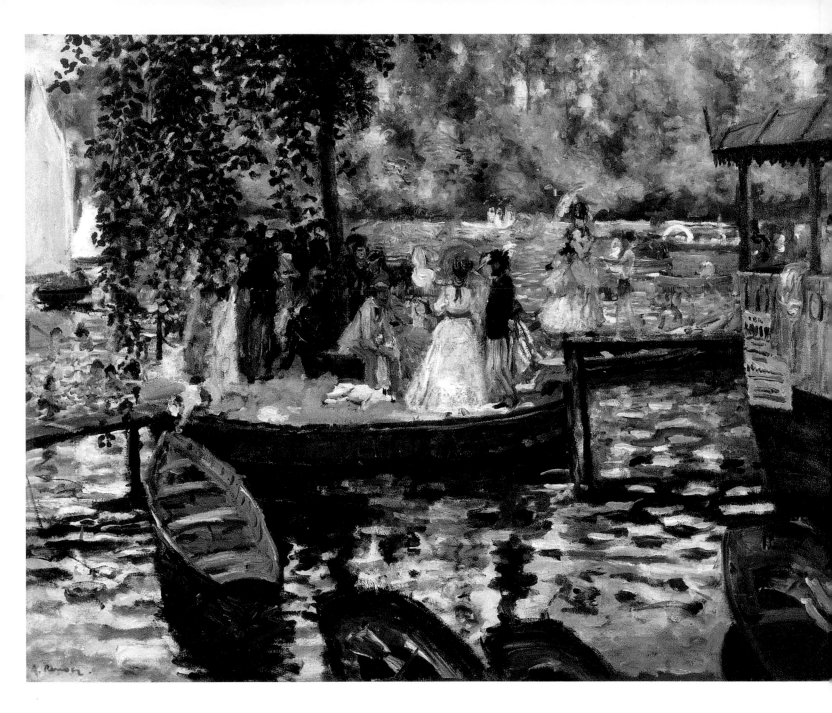

3. *La Grenouillère*,
 1869, Oil on canvas,
 66 x 81 cm,
 Stockholm, Statens
 Konstmuseer

An organic, almost physical sense of himself as part of the city was even then, in childhood, shaping the future artist's work. He saw beauty in the narrow, almost mediaeval streets of old Paris, in the heterogeneity of the elements of Gothic architecture, in the never-corseted figures of the female market traders. And he suffered from the fact that the old Paris, his Paris, was being destroyed. Ironically, it was the period of Renoir's childhood and youth that saw the greatest burst of reconstruction and modernization in the history of the city.

For a time, probably in 1859, Renoir worked for a Monsieur Gilbert on the Rue du Bac painting screens which served as portable religious images for missionaries. At this time he bought all he needed to work professionally in oils and painted his first portraits. The archives of the Louvre contain a permit issued to Auguste Renoir in 1861 to copy paintings in the museum. Finally, in 1862 Renoir passed the examinations and entered the Ecole des Beaux-Arts and, simultaneously, one of the independent studios, where instruction was given by Charles Gleyre, a professor at the Ecole des Beaux-Arts.

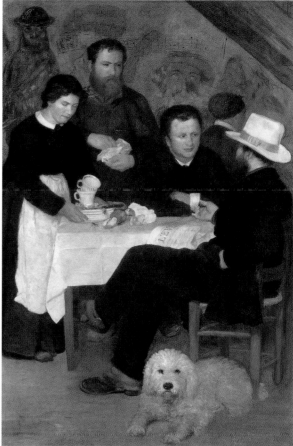

The second, perhaps even the first, great event of this period in Renoir's life was his meeting, in Gleyre's studio, with those who were to become his best friends for the rest of his days and share his ideas about art. In the studio Renoir immediately noticed a tall youth "with the elegance of people who let their servant put some wear on a new pair of boots for them [4]." Jean-Frédéric Bazille was indeed from a rich family. His parents owned an estate near Montpellier and were able to provide him with enough money to rent a studio in Paris. Even more important was the fact that his parents knew Edouard Manet, and Bazille had visited his studio many times. "You understand, Manet is as great for us as Cimabue and Giotto for the Italians of the Quattrocento. Because a Renaissance is beginning and we need to take part in it," he told Renoir [5]. It was Bazille who first began, even at that time, to speak of the need to form a group. It did happen, but at a later date, when Bazille had already met his untimely death in the Franco-Prussian War. He never did get to exhibit together with the others and he dubbed an Impressionist. According to Renoir, Bazille was the one who brought Alfred Sisley to Gleyre's studio. Perhaps, he was mistaken though, and Sisley found his own way there. Sisley was born in Paris, to a French mother and an English father.

4. *At the Inn of Mother Anthony*, 1866, Oil on canvas, Nationalmuseum, Stockholm

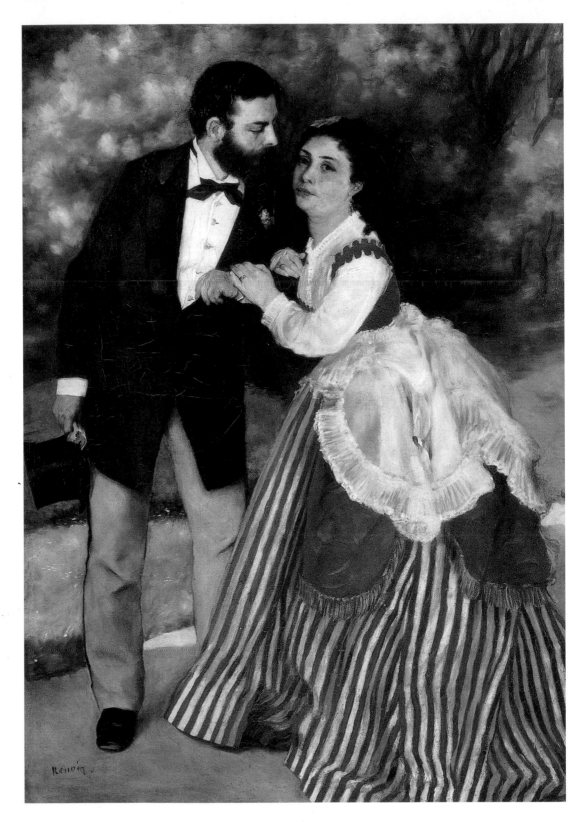

5. *Alfred Sisley and his Wife*, 1868,
 Oil on canvas,
 105 x 75 cm,
 Cologne, Wallraff-
 Richartz-Museum

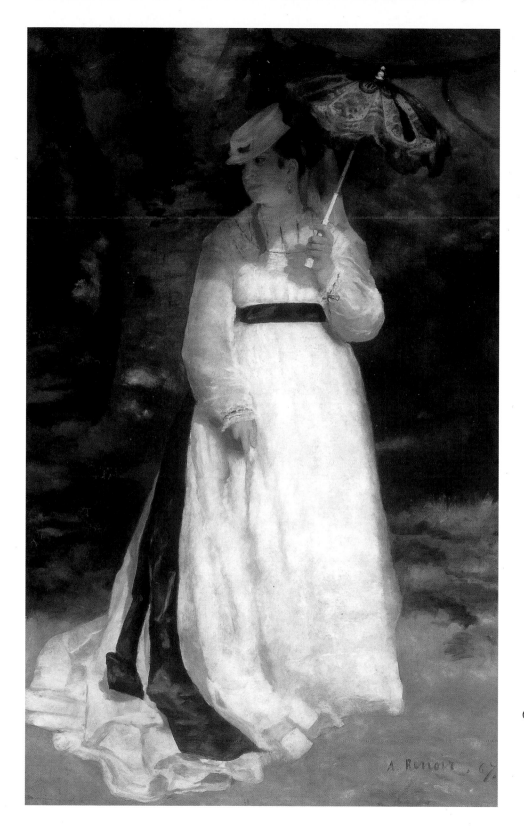

6. **Lisa** (*Woman with a Parasol*), 1867,
Oil on canvas,
184 x 115 cm, Essen,
Folwang Museum

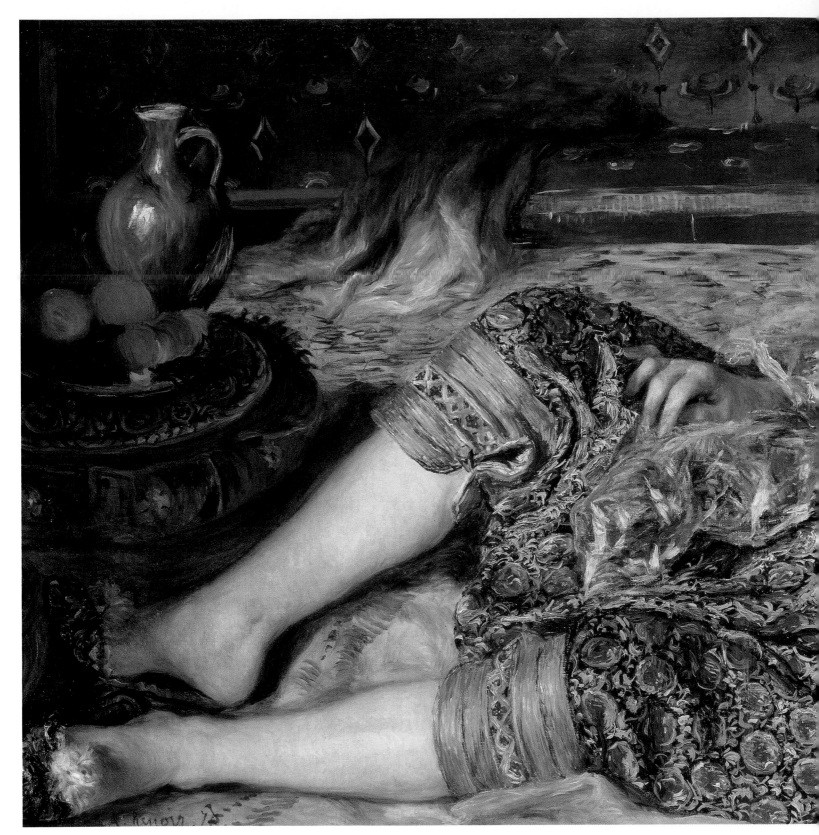

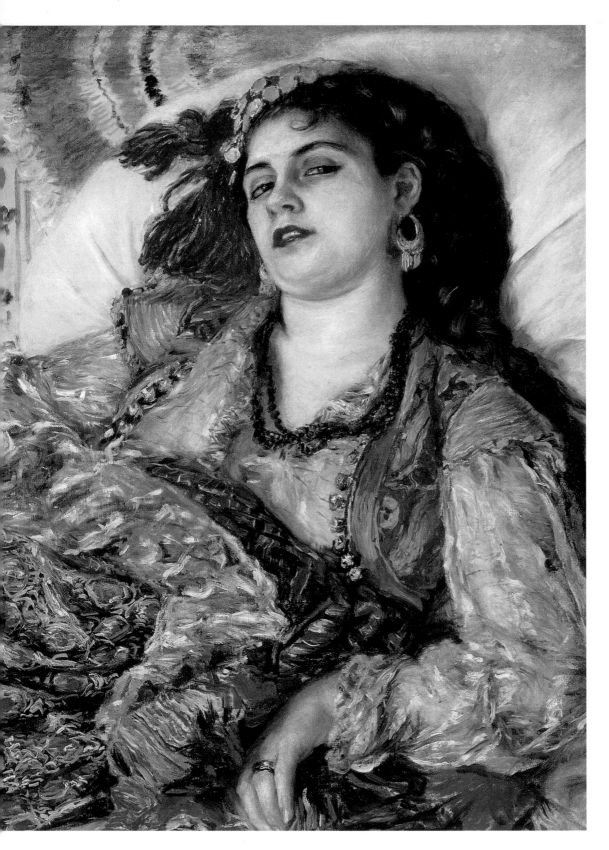

7. ***Odalisque*** (*Woman of Algiers*), 1870, Oil on canvas, 69.2 x 122.6 cm, Washington (DC), National Gallery of Art, Chester Dale Collection

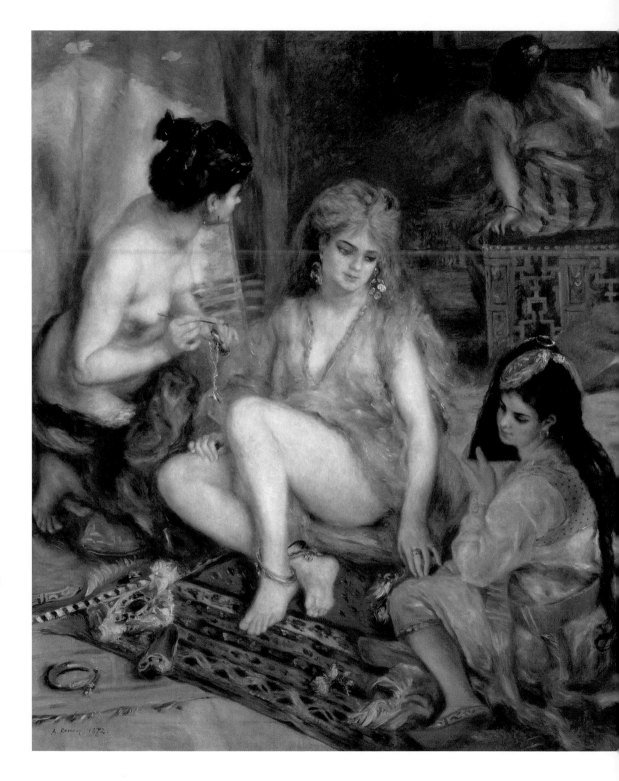

8. ***Interior of a Harem in Montmartre*** (*Parisian Women Dressed in Algerian costumes*), 1872, Oil on canvas, 156 x 128.8 cm, Tokyo, National Museum of Western Art, Matsukata Collection

When Jean-Frédéric Bazille first walked home from the studio with Renoir, they dropped into the Closerie des Lilas and Renoir asked him why he had wanted to talk to him. "Because of your way of drawing," Bazille replied. "I think you are somebody. [6]" Besides, Renoir made a brilliant showing in all the compulsory competitions, earning the highest awards for drawing, perspective, anatomy and "likeness", which is incontestable evidence of the fact that his years with Gleyre were not spent in vain. Renoir told his son with satisfaction that he had once painted a nude following all the rules that Gleyre had taught them. The Professor was astonished: it seems that his pupil, having perfectly mastered the science of painting, nevertheless continued to work "for his own amusement".

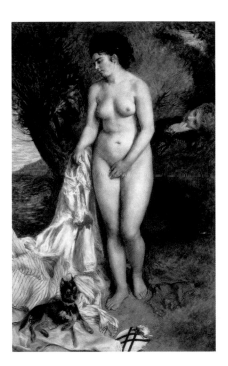

As with every artist, Renoir's passions in art altered with age, but from childhood the Louvre remained for him something unassailable. "It is in the museum that people learn how to paint," he said. "I often argued about that with some of my friends who put up against me the absolute preferability of working outside, among nature. They disparaged Corot for reworking his landscapes in the studio [7]."

Much later, when he was no longer young and already a mature artist, Renoir had the opportunity to see Rembrandt in Holland, Velázquez, Goya and El Greco in Spain, Raphael in Italy.
His encounter with each of the Old Masters brought him joy: "You have to be able to take from each master that satisfaction that he wanted to give us... But it is there, in the museum, that you get a taste for painting that nature alone cannot give you [8]".

At that time, however, when the friends gathered at the Closerie des Lilas and Renoir lived and breathed ideas of a new kind of art, he always had his own inspirations in the Louvre. "For me, in the Gleyre era, the Louvre was Delacroix [9]" he confessed to Jean. The death of Eugène Delacroix in 1863 caused the whole young generation of French artists to realize what the painting of the great Romantic had been for them.
In Delacroix's painting Renoir probably saw some kindred aspect, something particularly close to himself.
The period of study under Gleyre proved a short one. In 1863 everyone was obliged to leave the studio as it closed down. Jean Renoir claims that his father did so before the others, because he had no money to pay for his lessons. Whatever the case, a time of hardship and searching for paying jobs began — a time, though, which also brought the joy of new encounters, new discoveries in painting and the acquisition of new friends.

9. ***Bather with a Griffon***,
Oil on canvas,
184 x 115 cm, São
Paulo, Museu de Arte
de São Paulo, Assis
Chateaubriand

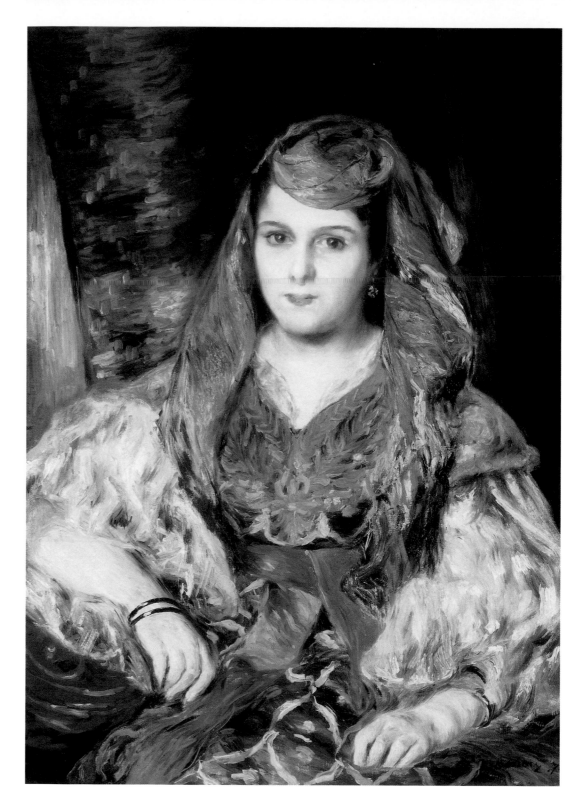

10. **The Algerian**
(*Madame Clémentine
Stora in an Algerian
costume*), 1870,
Oil on canvas,
84.5 x 59.6 cm,
Fine Arts Museum,
San Francisco (CA)

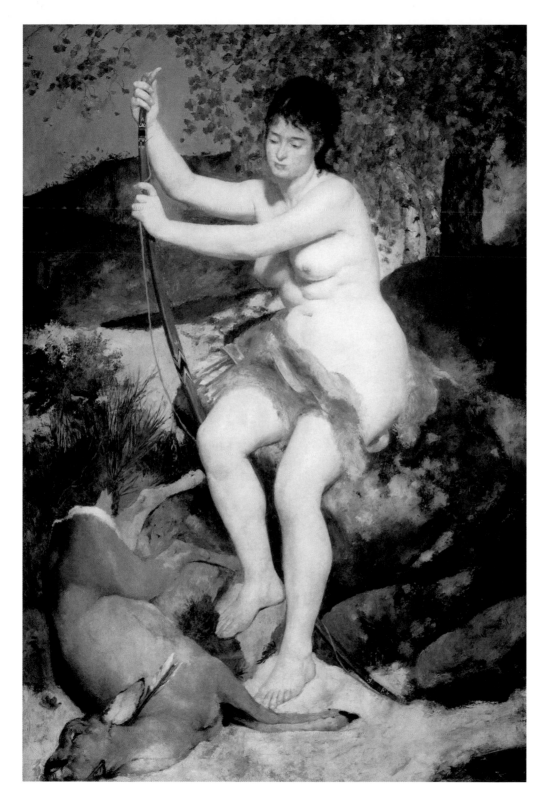

11. *Diane the Huntress*,
 1867, Oil on canvas,
 199.5 x 129.5,
 Washington (DC),
 National Gallery of
 Art, Chester Dale
 Collection

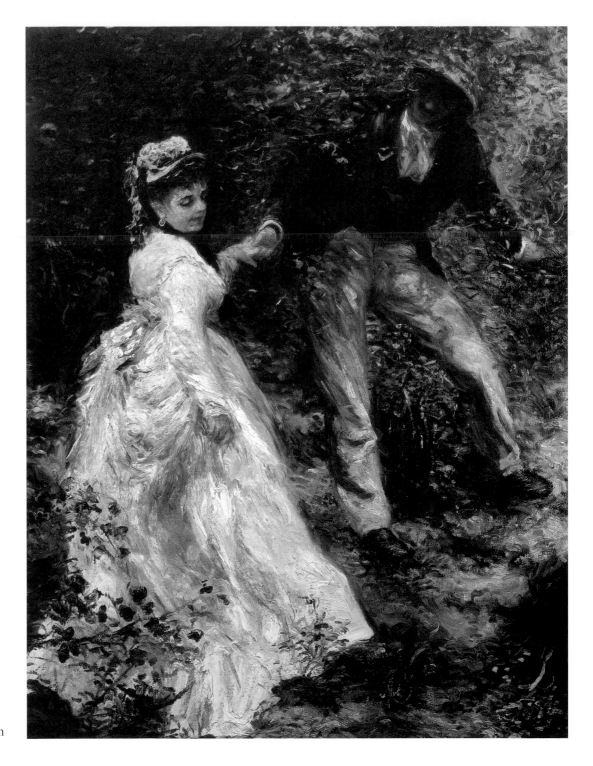

12. *The Promenade*,
1870, Oil on canvas,
80 x 64 cm, Los
Angeles (CA), The
J. Paul Getty Museum

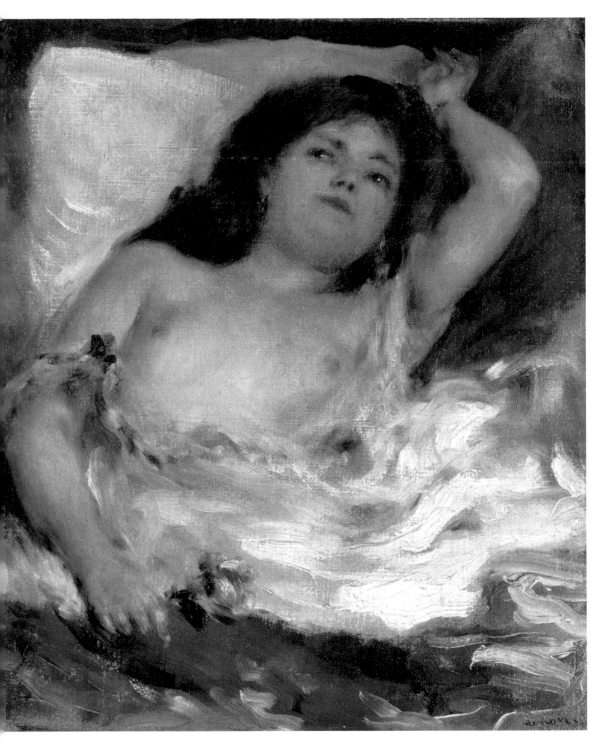

13. *Half-naked Woman Lying Down: the Rose*, ca. 1872, Oil on canvas, 28 x 25 cm, Paris, Musée d'Orsay

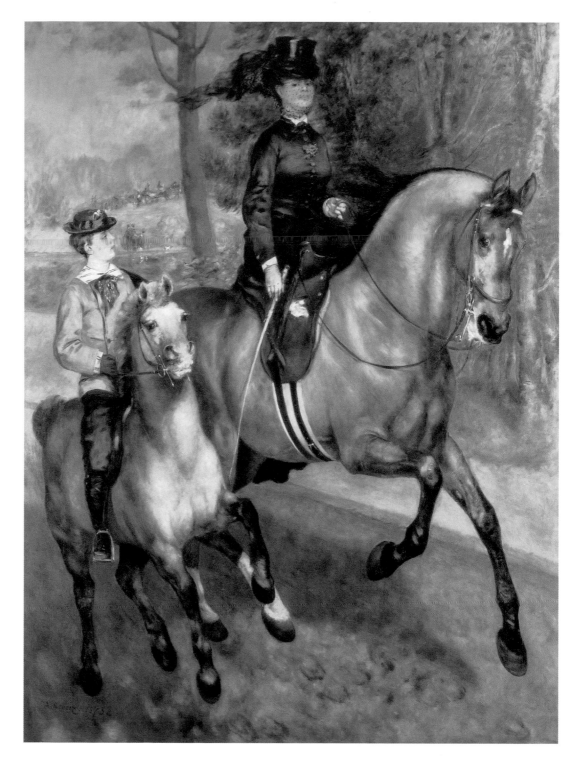

14. **Riders in the Bois de Boulogne**, (Madame Henriette Darras), 1873, Oil on canvas, 261 x 226 cm, Hamburg, Kunsthalle

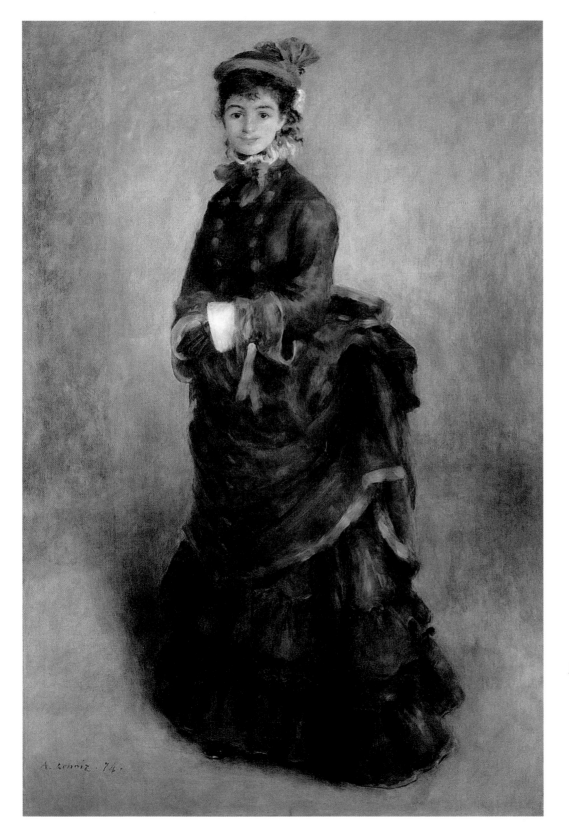

15. **The Parisienne**
(Henriette Heriot),
1874,
Oil on canvas,
160 x 106 cm,
Cardiff, National
Museum of Wales

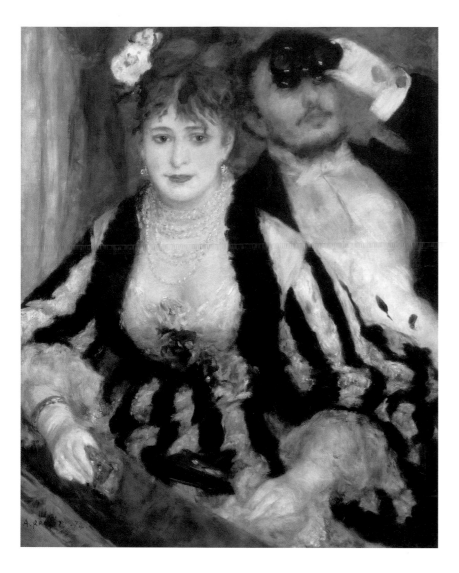

16. **The Box**, 1874,
 Oil on canvas,
 80 x 63.5 cm,
 London, Courtauld
 Institute Gallery

17. **Nude in the Sun**,
 1875, Paris, Musée
 d'Orsay

The year 1863 was marked by an outstanding event in the artistic life of Paris: on the orders of Napoleon III, alongside the official Salon of the French Academy, a Salon des Refusés was opened at which Manet's *"Luncheon on the Grass"* (*Le Déjeuner sur l'herbe*) caused a storm of controversy. From that moment the name of Edouard Manet became inseparably linked with the idea of a new kind of art. From the mid-1860s Manet was a permanent customer at the Café Guerbois on the Avenue de Clichy (formerly the Rue Grande-des-Batignolles), close to his apartment on the Boulevard des Batignolles. Manet's presence drew to the café artists, writers and critics close to the circle springing up around the new art.

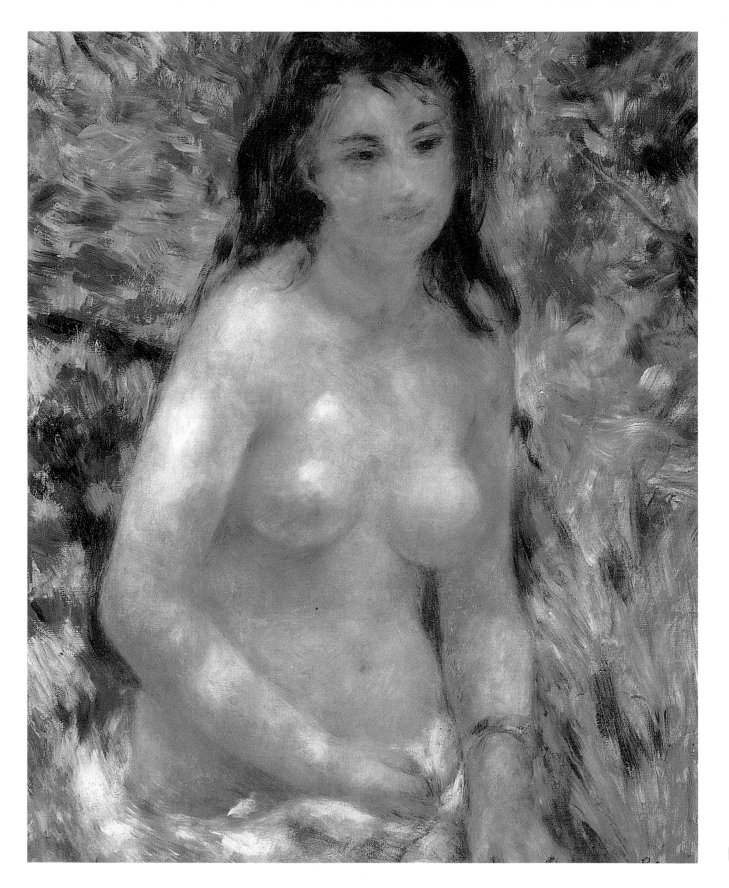

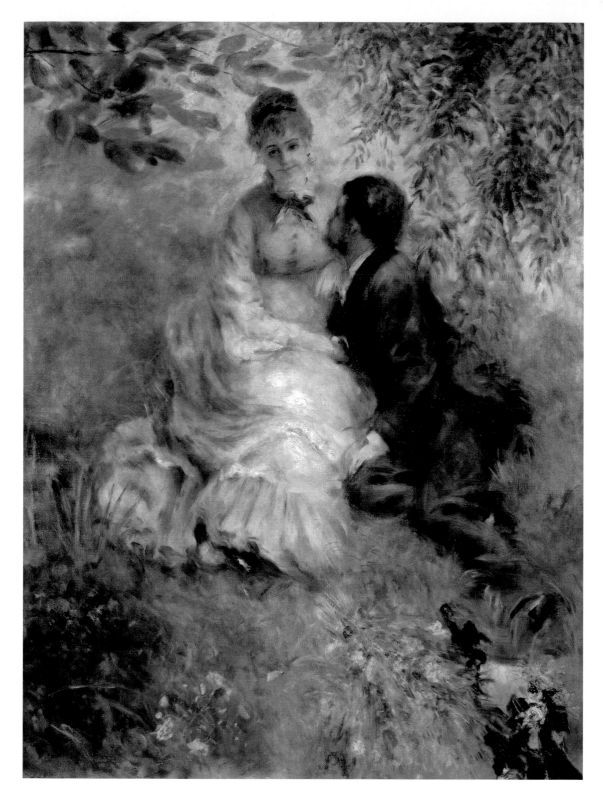

18. *The Lovers*, ca. 1875,
Oil on canvas,
175 x 130 cm,
Prague, Nàrodni
Galerie v Praze

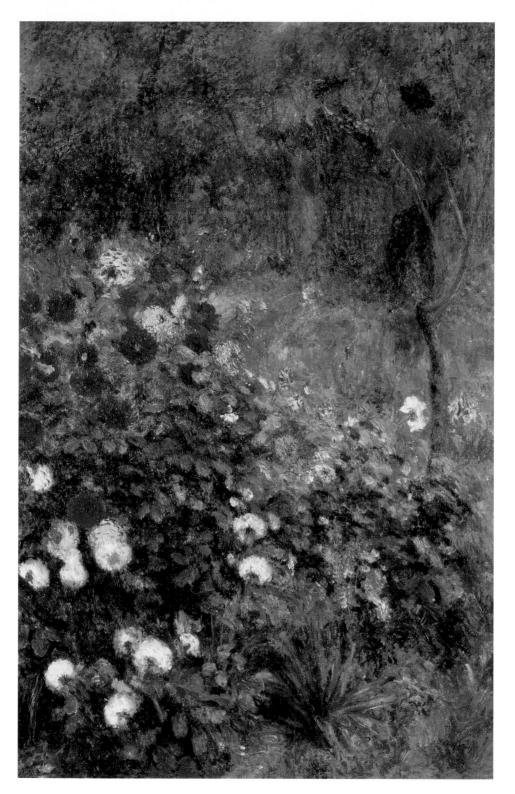

19. **Garden in the Rue Cortot, Montmartre**, 1876, Oil on canvas, 151.8 x 97.5 cm, Pittsburgh (PA) Carnegie Museum of Art

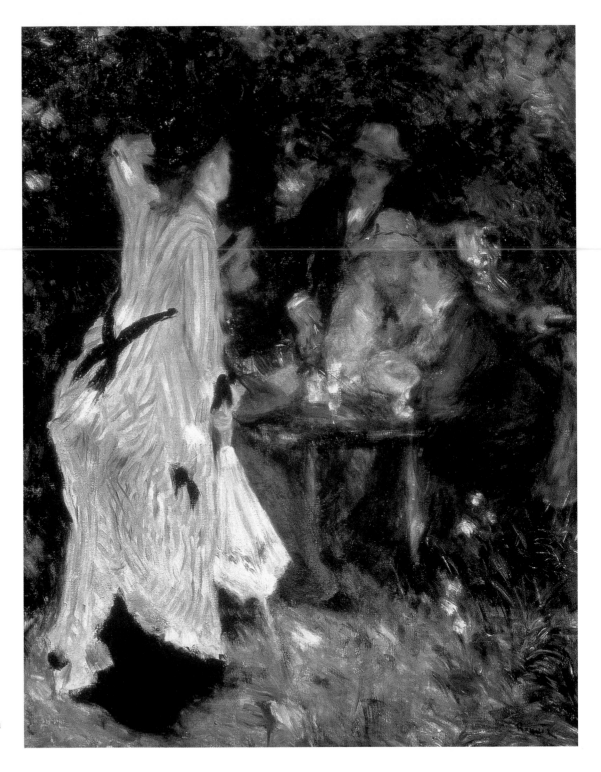

20. *In the Garden,* "La
Tonnelle", Oil on
canvas, 81 x 65 cm,
Moscow, The Pushkin
Museum of Fine Arts

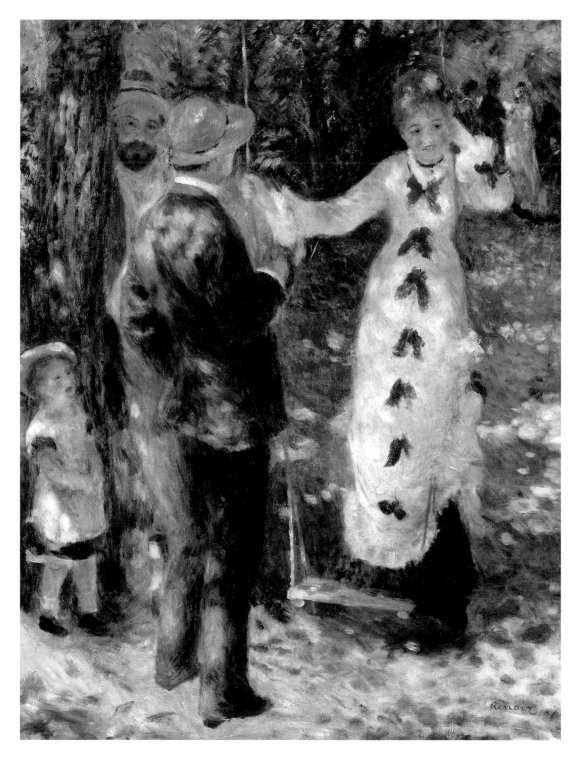

21. *The Swing*, 1876,
oil on canvas,
92 x 73 cm, Musée
d'Orsay, Paris

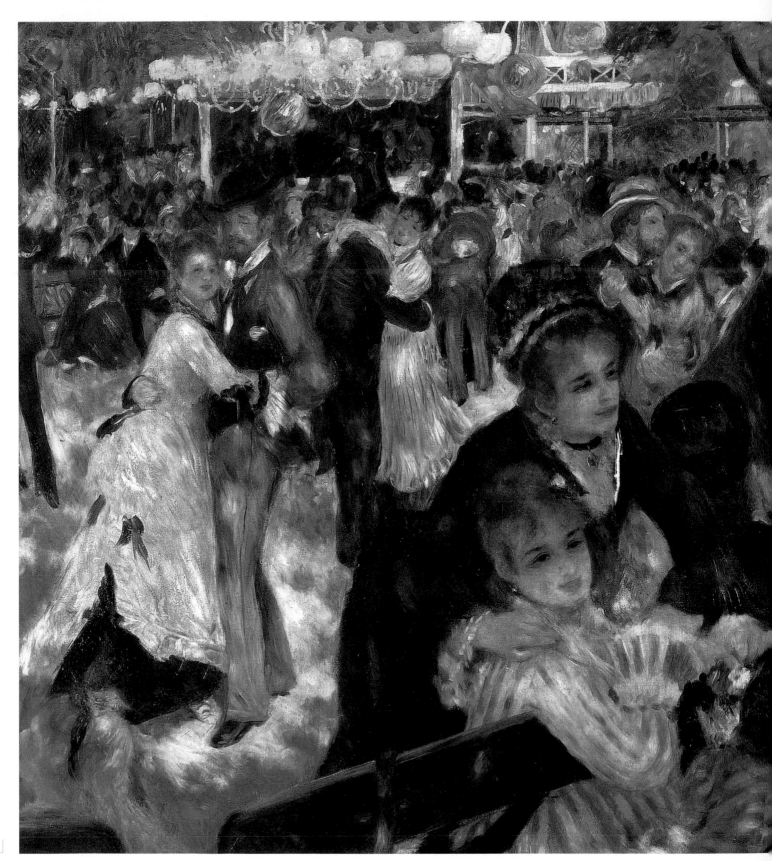

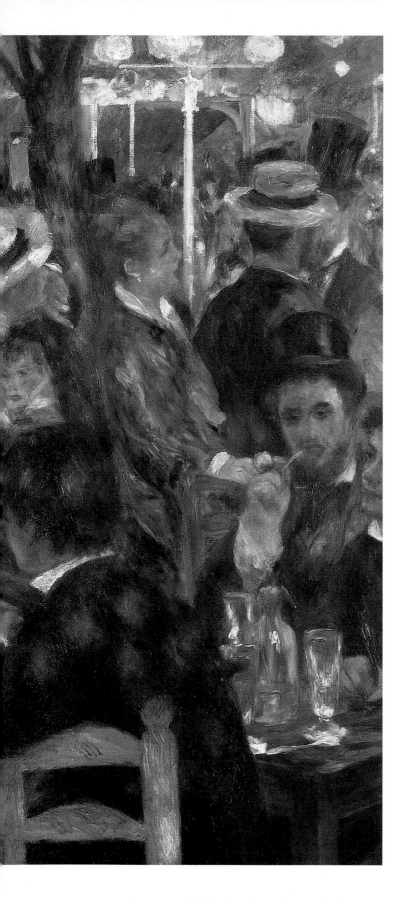

22. ***The Ball at the
Moulin de la Galette***,
1876, Oil on canvas,
131 x 175 cm, Paris,
Musée d'Orsay

23. *Lady in Black*, ca.
 1876, Oil on canvas,
 63 x 53 cm,
 St Petersburg,
 Hermitage Museum

24. *The Reading of the
 Part*, 1874-1876,
 Oil on canvas,
 90 x 70 cm, Reims,
 Musée des Beaux-Arts

Renoir and his friends also took themselves there from the Left Bank.

The years between 1863 and 1874 might be called the *"plein-air* decade" (painting directly from nature) in Renoir's biography, because it was at that time that the future Impressionist mastered this "outdoor" style of painting. Renoir was still short of money. Life in Paris was not easy, but he did have friends. With no permanent home of his own in Paris, he sometimes lived with Monet, sometimes with Sisley. Bazille, who was better-off than the rest, did not abandon Renoir, Monet and Sisley. He was the one who paid the rent of the studio where they all worked together.

"One should always be ready to set off for the motif," he told Jean. "No luggage. A toothbrush and a piece of soap [10]."

The geographical scope of Renoir's movements at that time was not particularly large — he had no money to travel far — but there were enough attractive motifs in the area around Paris. The more so, since it was on them that the Barbizon school had developed and Renoir and his friends felt themselves to be its direct successors as landscape painters. The Forest of Fontainebleau provided an inexhaustible stock of subject matter. Renoir and his friends acquired their own favourite places.

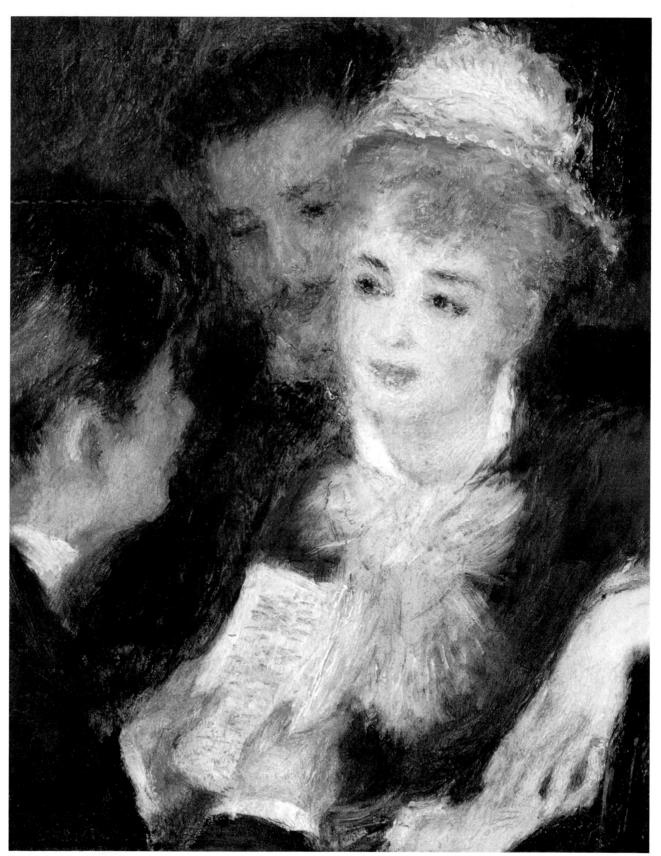

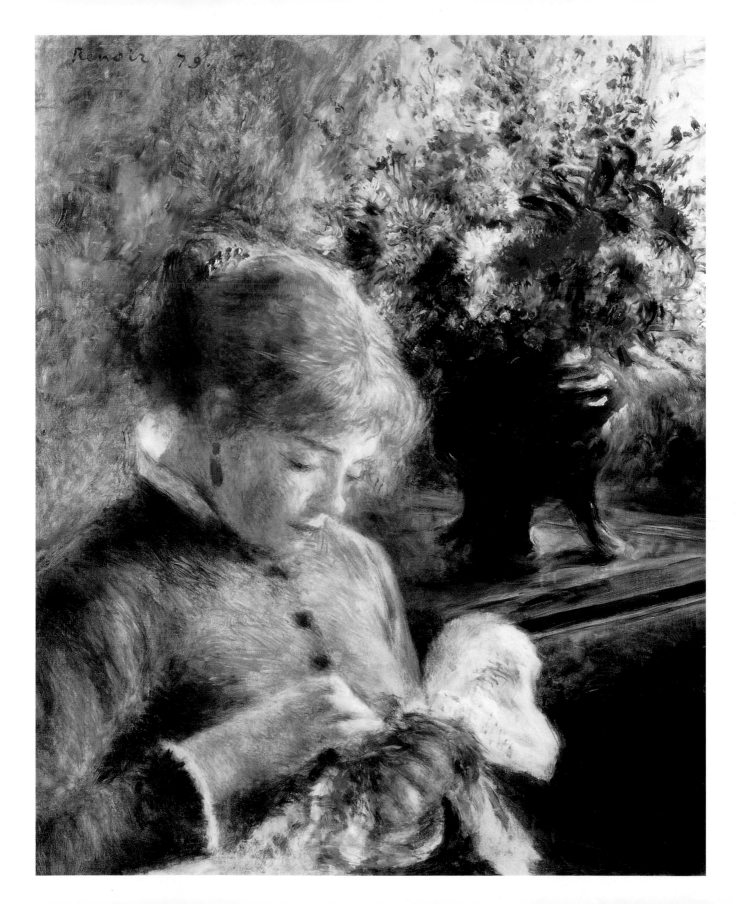

But in Paris too at that time it was possible to find real *plein-air* subjects: Monet and Renoir went into raptures painting the Seine near the Chatou bridge, where, at La Grenouillère, among the many little islands, Alphonse Fournaise opened the restaurant that became one of the future Impressionists' favourite places. Fournaise often refused to take Renoir's money.

In 1863 the Goncourt brothers mentioned in their diary the crudely and tastelessly painted main room of the inn at Marlotte and the extremely dubious public that gathered there; about 1866 Renoir depicted that same inn in the striking painting *"At the Inn of Mother Anthony"* (*Le Cabaret de la Mère Anthony*).

The scene Renoir recreated on a large canvas, about two metres high, was not invented. "In the picture painted at Mère Anthony's," Jean Renoir tells us, "you can recognize Sisley in the standing figure, and Pissarro in the one with his back to you. The clean-shaven character is Frank Lamy; in the depth of the scene, with her back to you, is Madame Anthony; in the left foreground is the servant-girl Nana ⁱ".

The construction of the painting is remarkable, though: the figures of the waitress and the seated gentleman, both facing the viewer and both cut off at the vertical edge of the canvas, and the group of figures disposed almost in a semicircle create the sense of a real space. And that achieved by a twenty-five-year-old artist two years before Manet produced his *"Luncheon at the studio"* (*Déjeuner à l'atelier*)!

In this period Renoir produced a large number of portraits. It was then more than ever that he painted Monet and Sisley, created his portrait of Sisley and his wife, and another of William Sisley, the artist's father. Renoir and Bazille painted each other in the studio they shared.

Researchers into Renoir's work believe that it is Le Cœur, and not Sisley, who is shown standing in *"At the Inn of Mother Anthony"* (*Le Cabaret de la Mère Anthony*). Thanks to Le Cœur, Renoir began to get commissions for portraits and this subsequently became his main source of income. And, most important of all, not without the indirect involvement of Le Cœur, Renoir acquired his first muse. The sister of Le Cœur's young lady, a girl named Lise Tréhot, became Renoir's girlfriend. Lise did more than just pose for Renoir from 1865 to 1872: she became the first model of that Renoiresque world that the artist began to create with her participation. For Renoir at that time, Lise Tréhot's face became a yardstick of feminine beauty. Perhaps Renoir had potential as a theatrical director, which he himself did not recognize, because later his paintings seemed to take the form of staged scenes from life. It was in his youth, however, in the period when the artist's main, and only actress was Lise that he played over in his canvases the experience provided by all his teachers in art, from Classical Greece to the modern era.

25. *Young Woman Sewing*, ca. 1879, Oil on canvas, 61.5 x 50.3, Chicago (IL), Mr. and Mrs. Lewis Larned Coburn Memorial Collection

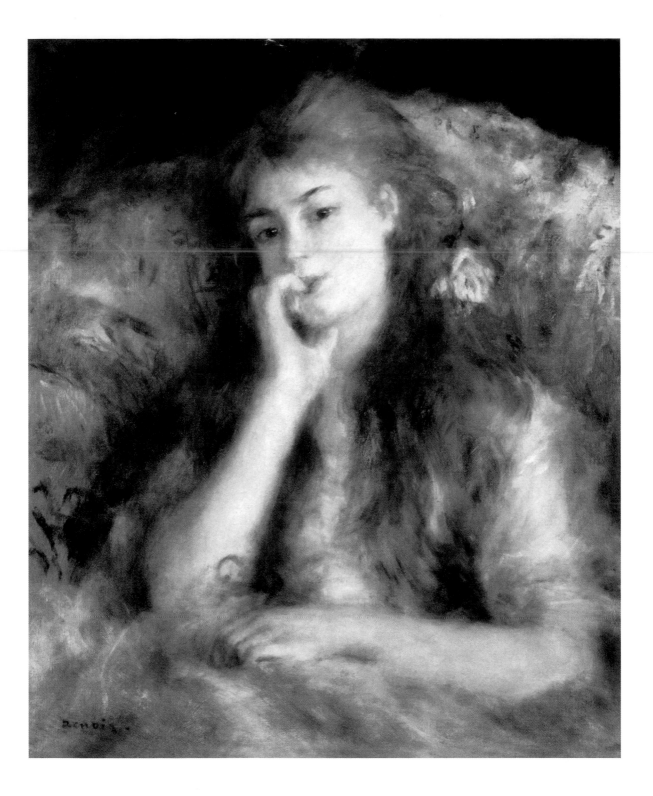

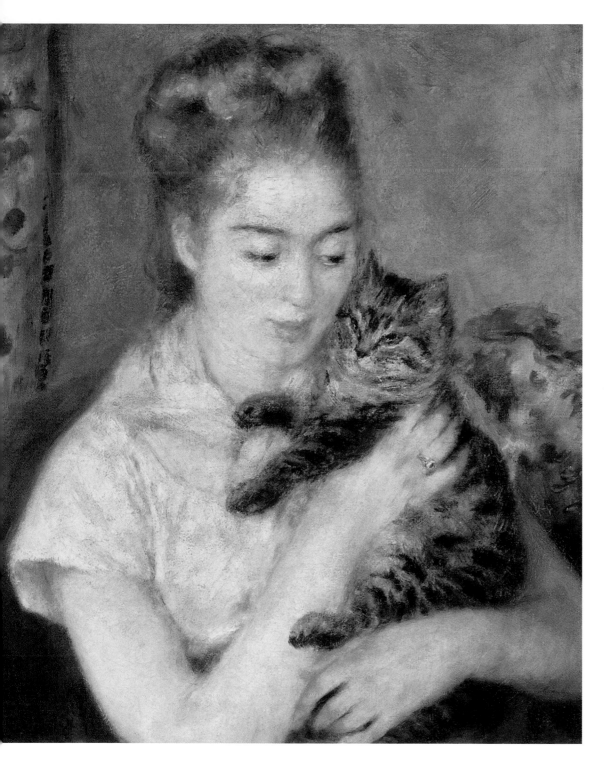

26. ***The Thought***,
 ca. 1876-1877,
 Oil on canvas,
 66 x 55.5 cm,
 Birmingham,
 The Barber Institute of
 Fine Arts, University
 of Birmingham

27. ***Woman with Cat***,
 ca. 1875,
 Oil on canvas,
 57 x 46.4 cm,
 Washington (DC),
 National Gallery of
 Art, Gift of Mr. and
 Mrs. Benjamin E. Levy

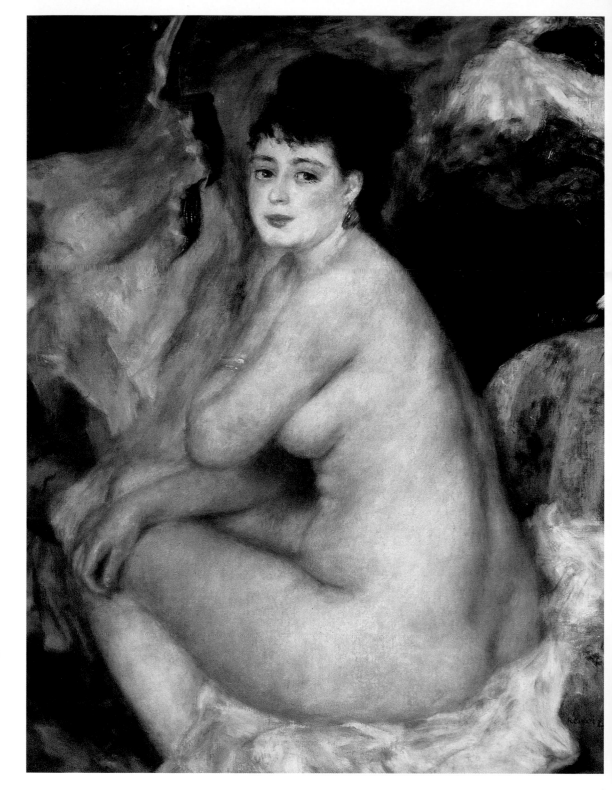

28. *The Nude*, 1876,
 Oil on canvas,
 92 x 73 cm,
 Moscow,
 The Pushkin
 Museum of Fine Arts

29. *The First Outing*,
 ca. 1876,
 Oil on canvas,
 65 x 49.5 cm,
 London,
 The National Gallery

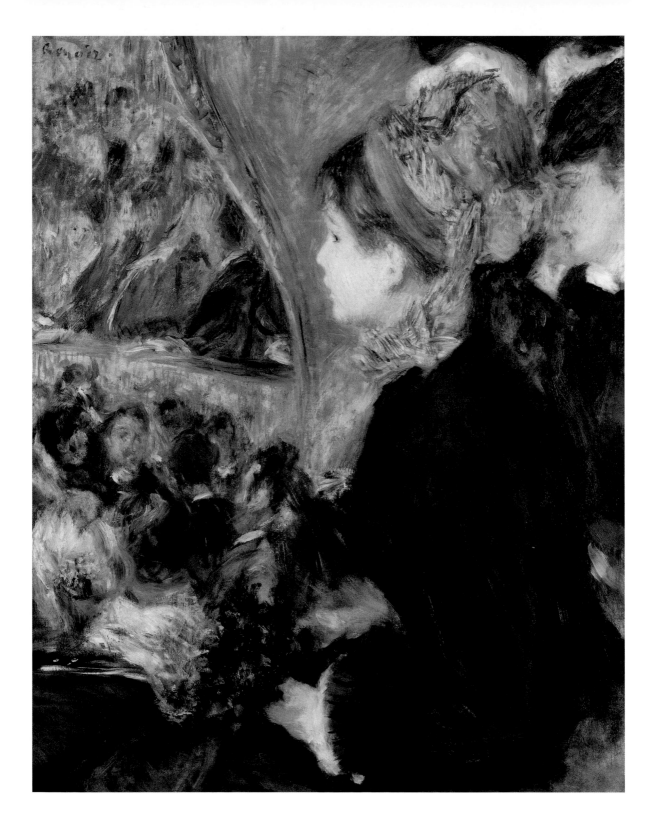

The apotheosis of this period came with paintings in the spirit of Eugène Delacroix — understandably, since it was through the mediation of his painting that Renoir's generation took in the achievements of their predecessors in the realm of colour. In the 1860s Manet too succumbed to the temptation of Romantic motifs from Delacroix's repertoire: a watercolour depicting an odalisque in oriental costume has survived. In 1870 Renoir painted an *"Algerian Woman"* (*La Femme d'Alger*). He dressed Lise in fine silk and oriental brocade glittering with gold embroidery. He adorned her splendid black hair with an orange plume and surrounded her with magnificent carpets. The eastern languor of Renoir's model was so theatrical, however, that it prompted a vicious caricature of the work by Cham. The artist returned to this subject in 1872, but now the title he gave the painting was completely candid: *"Parisian Women Dressed as Algerian Women"* (*Intérieur de harem à Montmartre ou Parisiennes habillées en algériennes*). Again Lise posed for him, but this was the last time. In 1872 she married the architect Georges Brière de l'Isle, a friend of Le Cœur.

Admittedly though, in 1864, even before he met Lise, one of his paintings was accepted for the Salon in the Grand Palais. It was entitled *"Esmeralda Dancing with Her Goat around the Fire which Illuminates a Crowd of Vagrants"* (*Esméralda dansant avec sa chèvre autour d'un feu qui éclaire tout un peuple de truands*). Immediately after the exhibition closed, Renoir destroyed it. The following year, 1865, the Salon accepted one landscape and his *"Portrait of William Sisley"* (*Portrait de William Sisley*). As a rule, the future Impressionists' paintings were not approved for display in the Salon, although the landscape painters of the older generation, Camille Corot and Charles Daubigny, asked the jury to do so. Renoir did not in any way disdain the Salon.

In the period in question, however, he was rejected less often than the others. In 1867, the jury did turn down *"Diana the Huntress"* (*Diane chasseresse*), on the other hand *"Lise with a Sunshade"* (*Lise à l'ombrelle*) was in the 1868 Salon, *"Summer"* (*En été*) in the 1869 Salon, *"Bather with a Griffon"* (*Baigneuse au griffon*) and *"Algerian Woman"* (*La Femme d'Alger*) in the 1870 Salon.

On 18 July 1870, normal life was interrupted when France declared war on Prussia. The very idea of war was alien to Renoir. Fate decreed that Renoir, who did not know the first thing about horses, was sent to the cavalry. He found himself in Bordeaux, then Tarbes. The painter's captain in the cavalry was very pleased with his achievements. The captain's daughter was interested in painting. Renoir gave her lessons and at the same time made portraits of her. The idyll ended unhappily, however. Renoir fell seriously ill and the doctors in the Bordeaux hospital only just managed to save his life.

30. *The First Step*, 1876,
Oil on canvas,
111 x 80.5 cm,
Private Collection

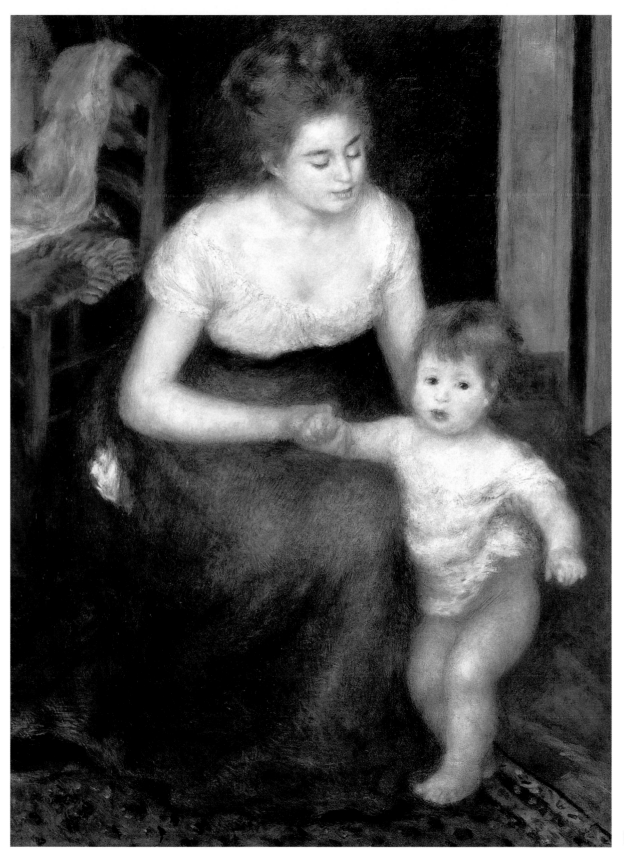

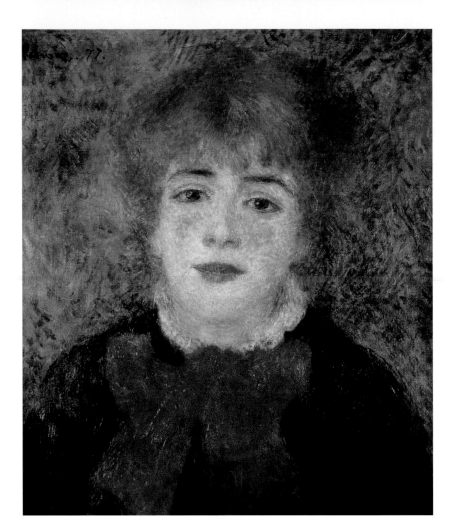

31. **Jeanne Samary**,
1877, Oil on canvas,
46 x 44 cm, Paris,
Musée de la
Comédie-Française

In March 1871, he was demobilized and returned to Paris — to the Latin Quarter, where before the war he had rented an apartment together with Bazille, and later with the musician Edmond Maître, who was also a lover of painting. It was there that he learned of Bazille's death — a shock which affected him more deeply than the war itself. The story of Renoir the cavalryman had its continuation in his painting. In 1872 he produced *"Riders in the Bois de Boulogne"* (*L'Allée cavalière au bois de Boulogne*). The woman who posed for the magnificent Amazon was Madame Darras, the wife of Captain Darras, whom Renoir had met through the Le Cœurs. The boy on the pony was Charles Le Cœur's son. There are two purely Renoiresque aspects to the painting. First, he was unable to resist the charm of a Parisienne "whose skin does not reflect light", the elegance of the black veil and the rose pinned to the black suit. The painting was rejected for the Salon.

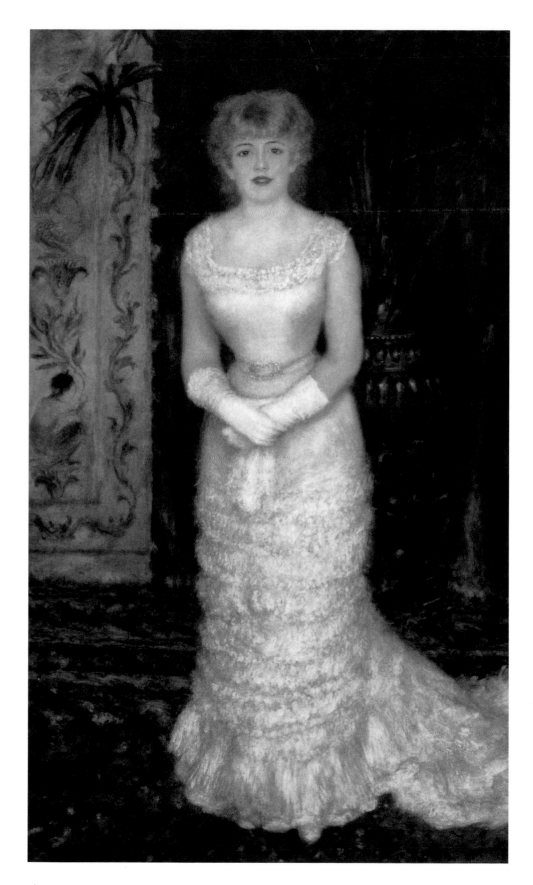

32. *Portrait of the actress*
Jeanne Samary,
1878, Oil on canvas,
173 x 103 cm,
The Hermitage,
St. Petersburg

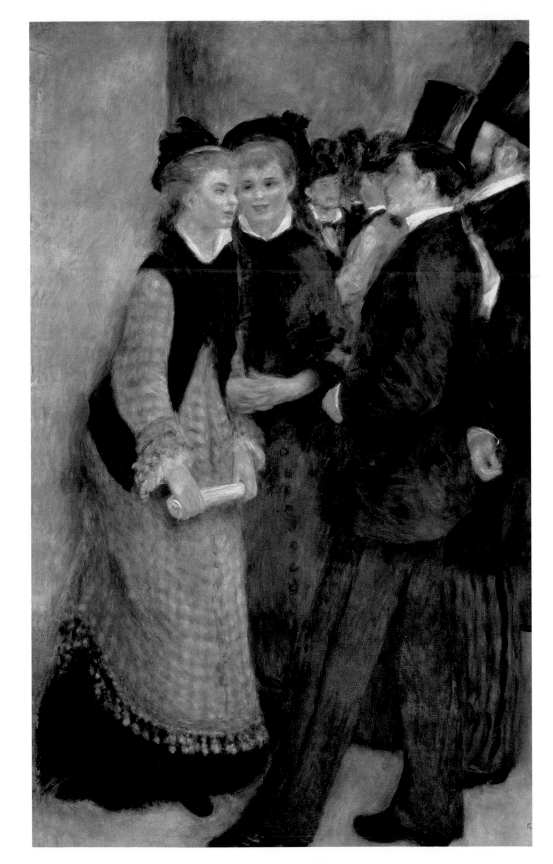

33. *The Exit of the Conservatory*, 1877, Oil on canvas, 187.3 x 117.5 cm, Merion (PA), The Barnes Foundation

34. *La Place Clichy*, ca. 1880, Oil on canvas, 65 x 54 cm, Cambridge, The Fitzwilliam Museum

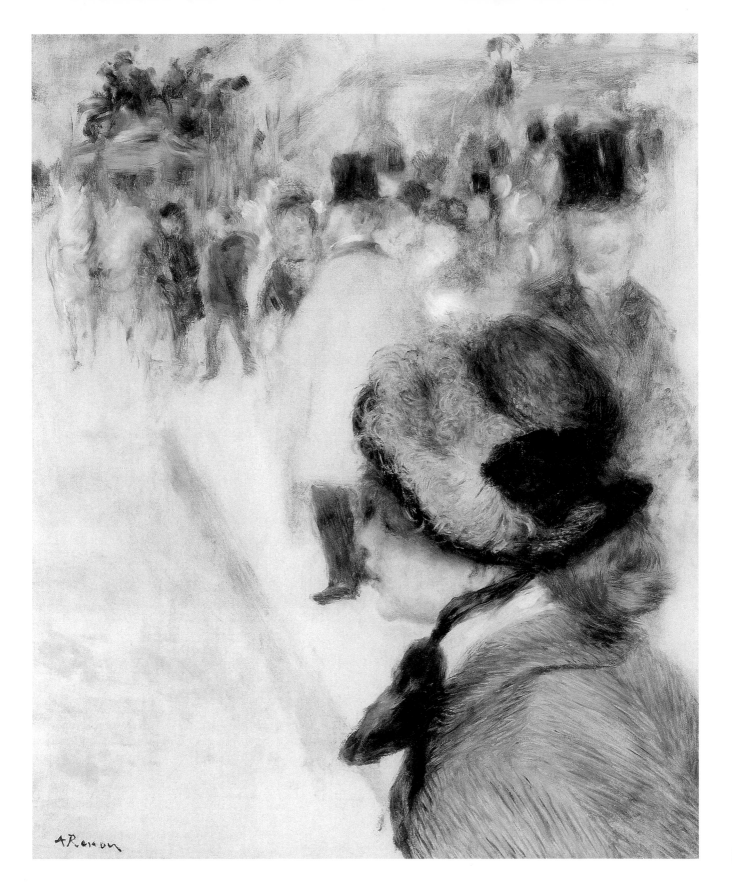

It was displayed at the Salon des Refusés organized in 1873 behind the Grand Palais. This probably dispersed Renoir's illusions about his possibly achieving a compromise with the official Salon. Finally, the association of artists about which Bazille and Pissarro had already been dreaming in the late 1860s came about. In an interview given to the magazine *La Vie Moderne* in 1880, Claude Monet said: "For some time already the jury had been systematically rejecting us, my friends and myself. What were we to do? Painting is not the whole story — you have to sell, you have to live. The dealers didn't like us. We had to exhibit, though. But where? ... Nadar, the great Nadar, who is an exceptionally kind person, provided us with premises...[12]"

The premises in question, the studio of the noted photographer Nadar, were located at number 35 on the Boulevard des Capucines.

For that reason, Edgar Degas proposed calling the group "La Capucine", in which case they could have taken the nasturtium (*capucine* in French) as their emblem. In the end they settled for the neutral title *Société anonyme coopérative d'artistes, peintres, sculpteurs, graveurs, etc.* It was decided that each member of the society would contribute ten per cent of the income received from the sale of paintings to a pool. They wanted to have as many people as possible participating. Degas invited two French artists living in London, James Tissot and Alphonse Legros, to exhibit together with him and his friends. Manet, naturally, was also invited, but he declined. According to one version, Manet declared that he would never exhibit his work alongside Cézanne, whose participation in the exhibition had been obtained by Pissarro. By Renoir's account, things were somewhat different. "Why should I go off with you young ones?" Manet asked. "After all, I am already accepted in the official Salon, which is the best battlefield. In the Salon my worst enemies are obliged to walk past my canvases.[13]"

As a result neither Manet, nor his friend Fantin-Latour, nor Tissot, nor Legros exhibited. Even Corot was somewhat disturbed by the venture, and he advised Antoine Guillemet not to become involved. Nevertheless, the organizers managed to bring together twenty-nine artists who presented 165 works. Edmond Renoir was responsible for the catalogue. Despite the fact that the majority of critics in Europe and America derided the exhibition, called it comic and announced that the artists had declared war on beauty, it aroused an exceptionally large response. The venture was not a commercial success, but an image of each of the Impressionists did indeed begin to take shape in the minds of interested visitors. Renoir displayed six oil paintings and one pastel. Viewers' attention was drawn by the large canvases: "*Dancer*" (*La Danseuse*), "*Parisienne*" (or *Lady in Blue*) — for which Henriette Henriot, an actress at the Odéon Theatre, posed, and "The Theatre Box" (*La Loge* or *L'Avant-scène*).

35. ***Young Girl with a Cat***, 1880, Oil on canvas, 120 x 94 cm, Williamstown (MA), Sterling and Francine Clark Art Institute

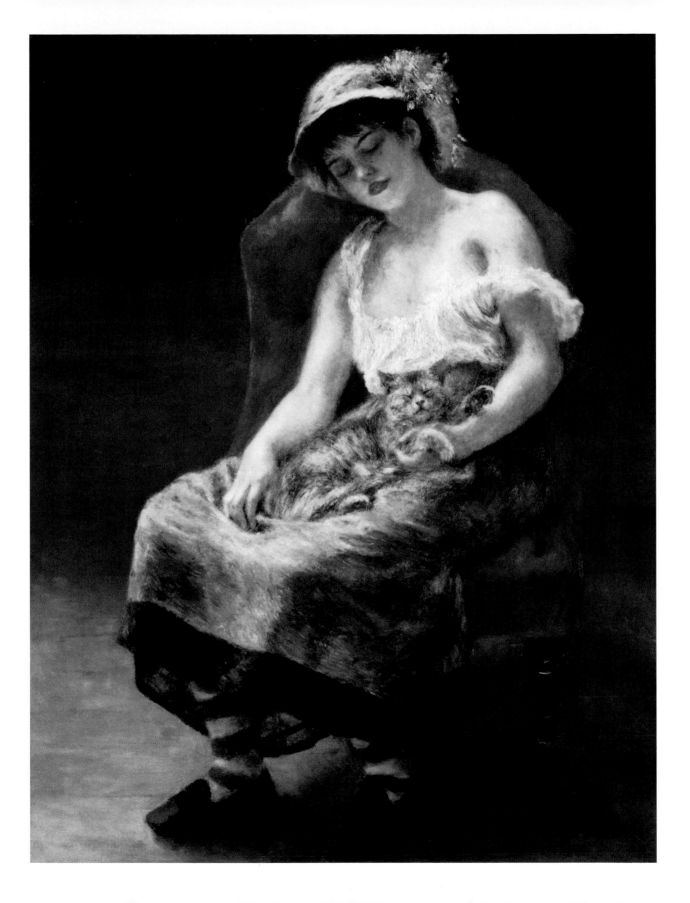

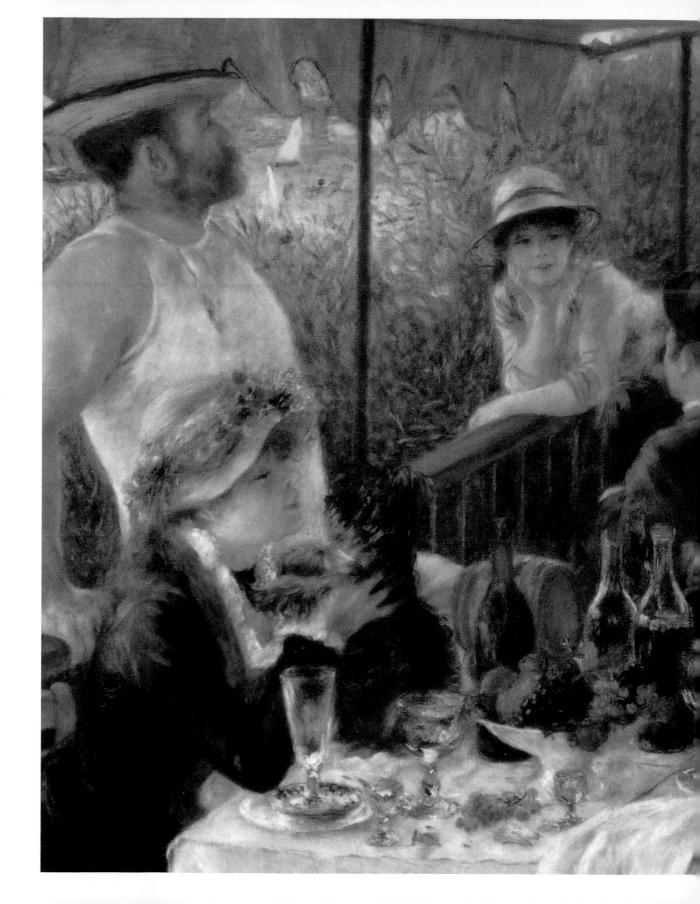

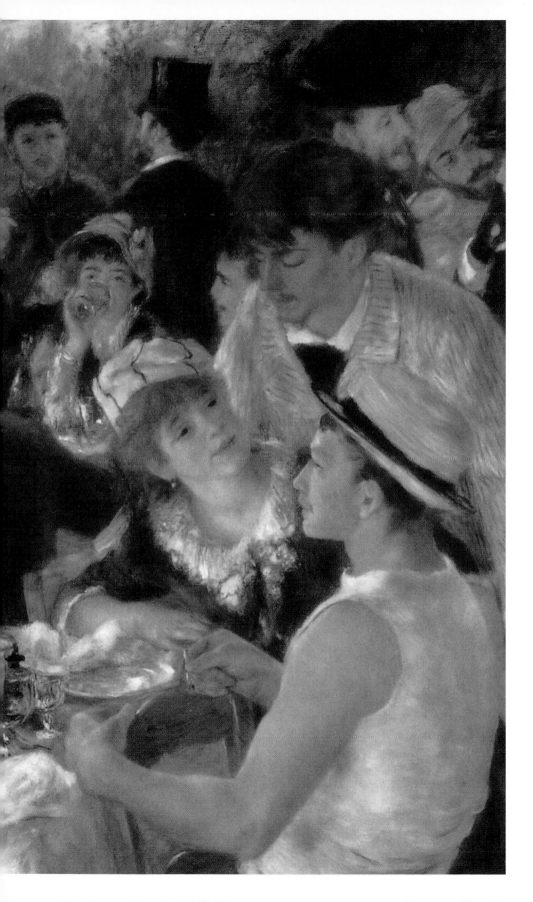

36. **The Lunch of the
Boaters**, 1880-1881,
Oil on canvas,
129.5 x 172.5 cm,
Washington (DC),
The Philipps
Collection

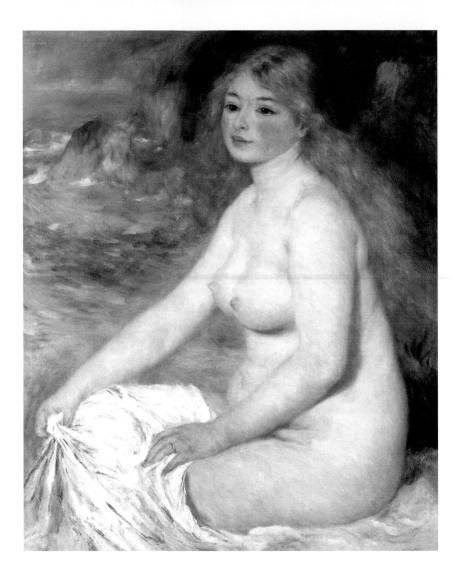

37. **Blond Bather**, 1881,
 Oil on canvas,
 82 x 66 cm,
 Williamstown (MA),
 Sterling and Francine
 Clark Art Institute

In "The Theatre Box" she became the archetype of the Renoir portrait: no allusions to her social status, character or mood — only the delight of porcelain skin, slightly painted lips and an elegant dress, only the transient charm of the Parisienne. "Renoir has a great future ahead of him," Burty wrote. "His *Avant-scène*, especially in the light, achieves absolute illusion. The powdered, dispassionate face of the lady, her white-gloved hands, one of which holds a lorgnette, while the other is plunged in the muslin of her handkerchief, the thrown back head and body of the man are pieces of painting worthy of both attention and praise.[14]" For the first time in this painting, a wave of light, harmonious, unrestrained colour broke across Renoir's canvas in conjunction with a composition worthy of the lessons provided by Classical teachers.

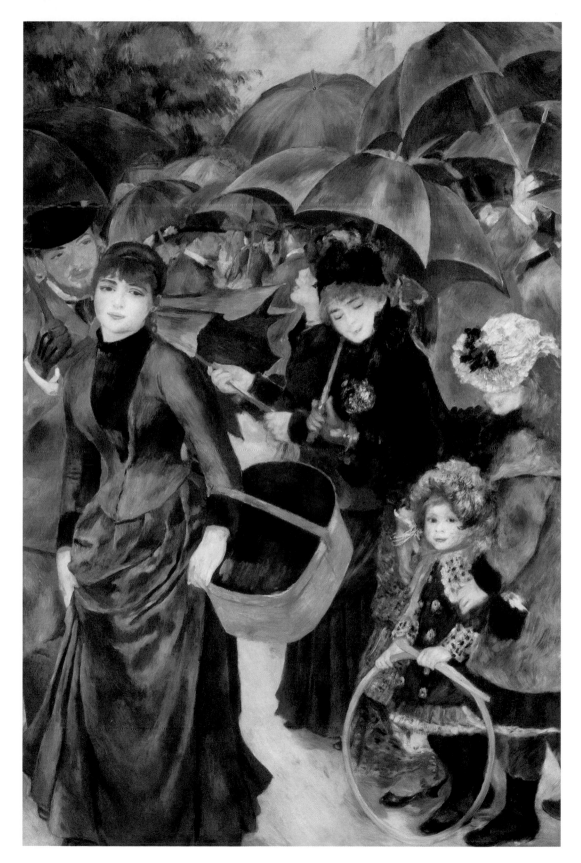

38. *The Umbrellas* (After
the Rainfall),
ca. 1881-1885,
Oil on canvas,
180.3 x 114.9 cm,
London, The National
Gallery

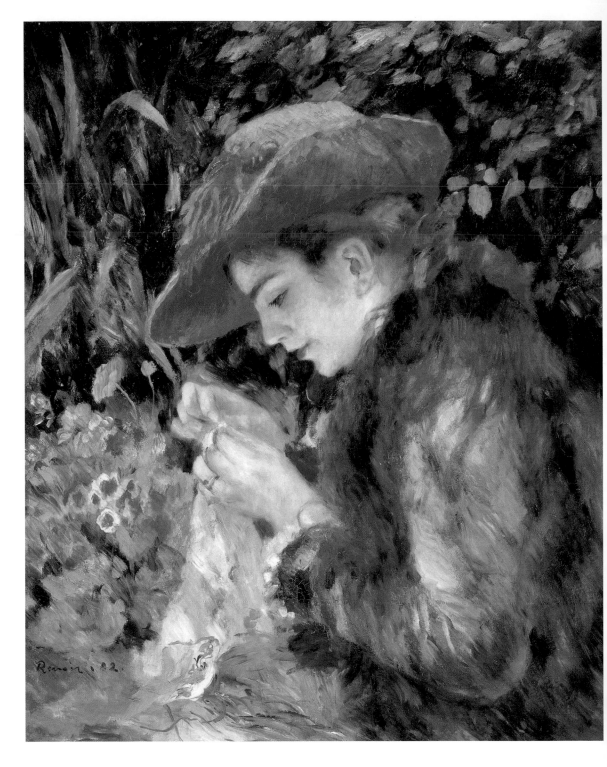

39. *Miss Marie-Thérèse
Durand-Ruel
Sewing*, 1882,
Oil on canvas,
64.8 x 53.8 cm,
Williamstown (MA),
Sterling and Francine
Clark Art Institute

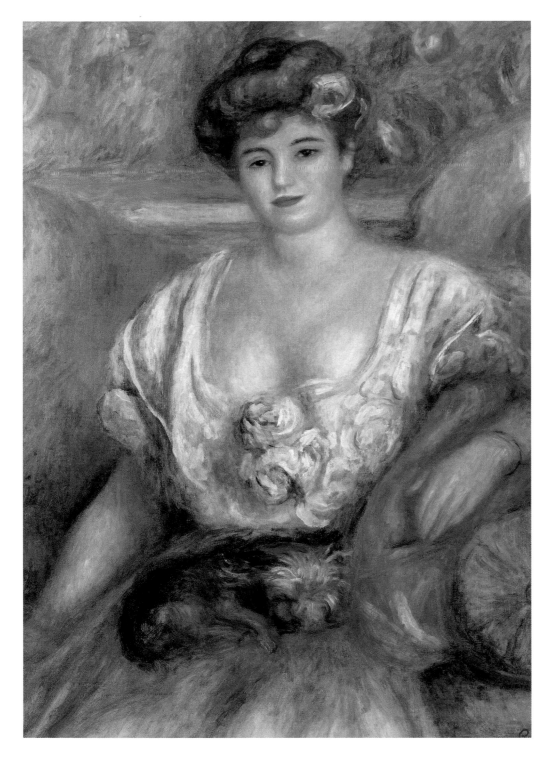

40. *A Woman's Bust,*
 Yellow Corsage,
 ca. 1883, Oil on
 canvas, 42 x 32 cm,
 Private Collection

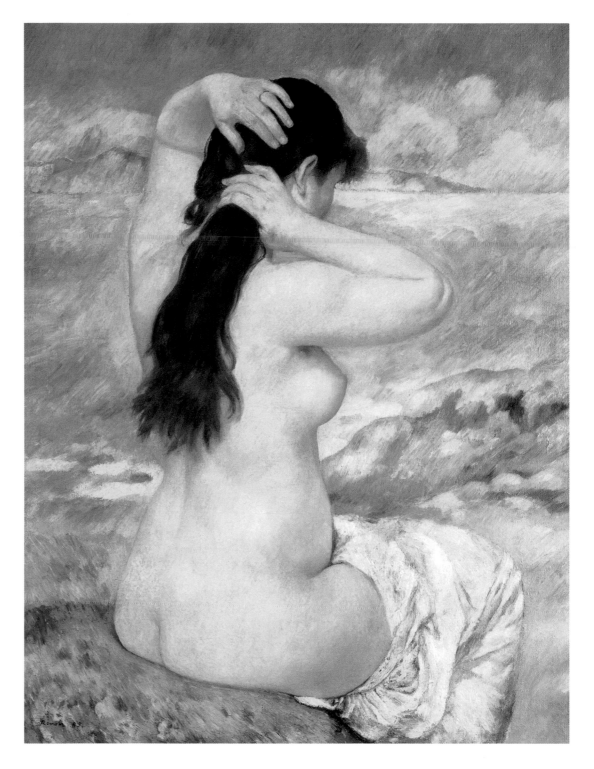

41. ***La Coiffeuse*** (*Bather Arranging her Hair*), 1885, Oil on canvas, 92 x 73 cm, Washington(DC), National Gallery of Art, Chester Dale Collection

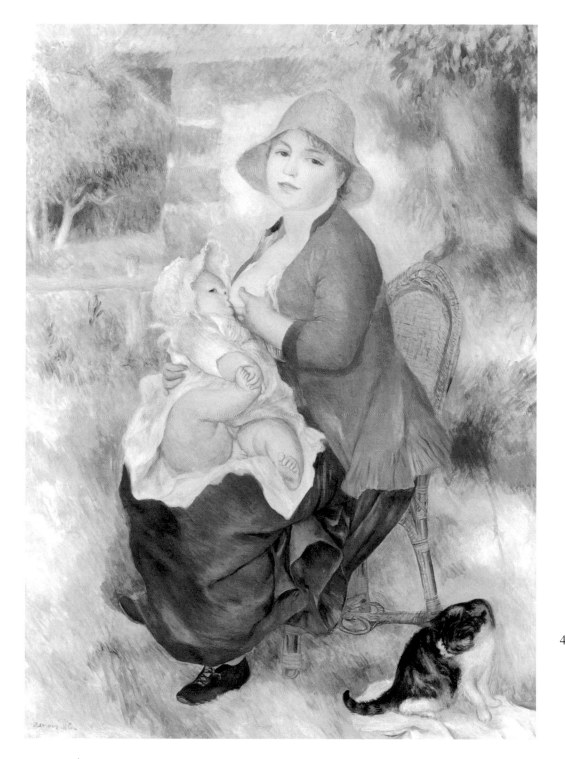

42. *Maternity – The
Child Breastfed*
(*Aline and Pierre*),
Third version, 1886,
Oil on canvas,
74 x 54 cm, Private
Collection

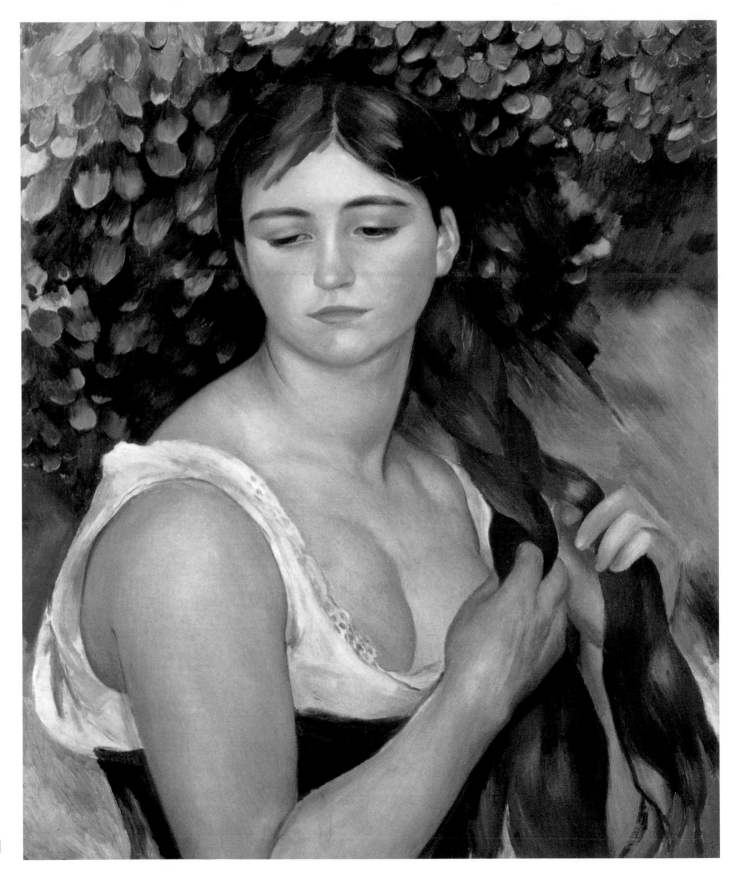

Yet the framework of diagonals in the strict pyramidal construction is not immediately striking: it is concealed by the large figures advanced towards the viewer. *La Loge* arouses vague associations with Caravaggio's compositions, and even stronger ones with Manet's *"Balcony" (Le Balcon)*. Renoir absorbed ideas and influences and then resolutely followed his own path.

As early as 1870, the critic Arsène Houssaye acknowledged those qualities in him: "Gleyre, his teacher, must be very surprised that he brought up a prodigal son like this, who laughs at all the laws of grammar, because he dares to do things his own way. But Gleyre is too great an artist not to recognize art however it might express itself [15]." For Renoir, the first Impressionist exhibition was the moment his vision of the artist was affirmed.

This period in Renoir's life was marked by one further significant event. In 1873 he moved to Montmartre, to the house at 35 Rue Saint-Georges, where he lived until 1884. Renoir remained loyal to Montmartre for the rest of his life. Here he found his *plein-air* subjects, his models and even his family. It was in the 1870s that Renoir acquired the friends who would stay with him for the remainder of his days.

One of them was the art-dealer Paul Durand-Ruel, who began to buy his paintings in 1872. Renoir said that "père Durand" was a courageous and honest man and that without him the Impressionists would not have survived. More than once he was on the brink of ruin, but he did not let them down. And even when Durand-Ruel was unable to buy paintings due to lack of money, he gave Renoir a certain sum every month.

At an unsuccessful sale that Renoir, Monet, Sisley and Berthe Morisot organized at the Hôtel Drouot in 1875, Victor Choquet, an official with the Customs administration, bought his first paintings by Renoir. That was the start of another long friendship. Choquet immediately commissioned Renoir to paint a portrait of his wife. Choquet was one of the first to grasp that it was Renoir and his friends who were the direct inheritors of eighteenth-century art. Renoir said that Choquet was "the greatest French collector since the time of the kings, and perhaps since the time of the popes [16]".

The 1870s in Montmartre were possibly the happiest time in Renoir's creative biography. The little neglected garden by the studio on the Rue Cortot that he began renting in 1875 became the *plein-air* setting which generated the finest paintings of this period. The garden itself, in which one or other of his friends could always be found, became a theme to be painted *"Garden in the Rue Cortot, Montmartre" (Le Jardin de la rue Cortot à Montmartre)*. Here he worked on *"Summer House" (La Tonnelle)*, *"The Swing" (La Balançoire)* and *"The Ball at the Moulin de la Galette" (Le Bal du Moulin de la Galette)* — one of the most important paintings he ever produced.

43. ***The Braid*** (*Suzanne Valadon*), 1884-1886, Oil on canvas, 56 x 47 cm, The Metropolitan Museum of Art, New York

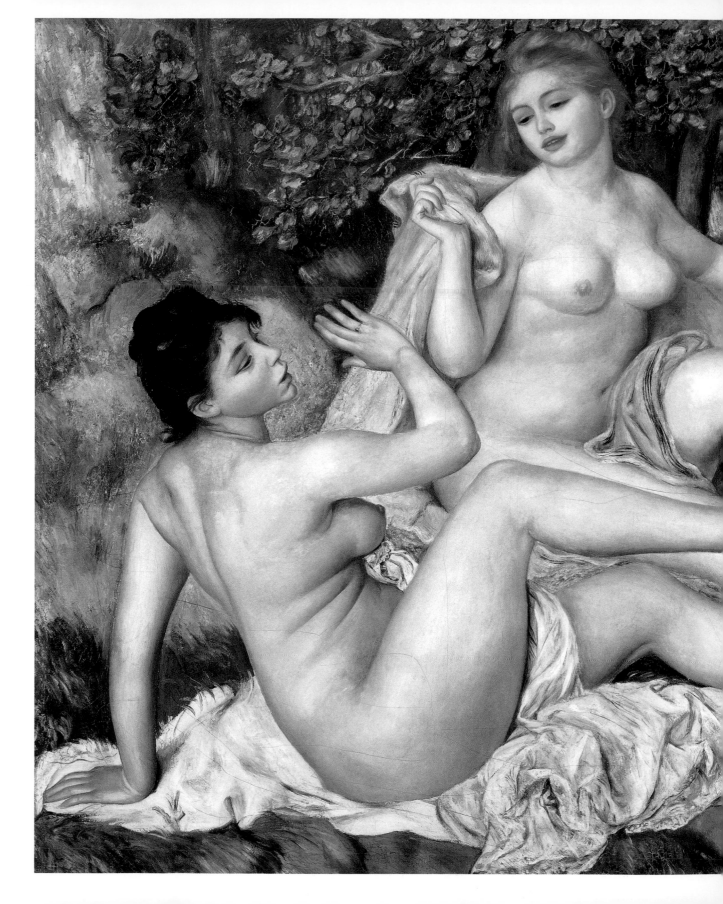

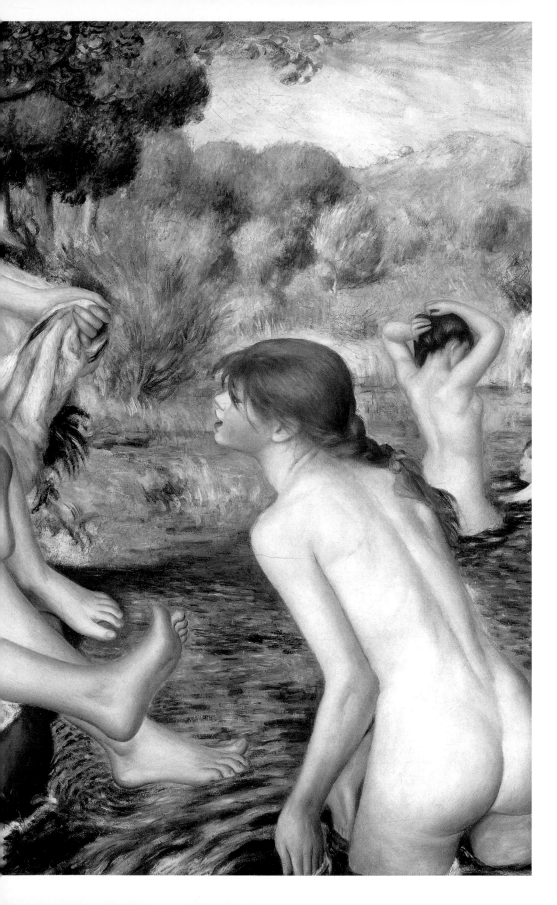

44. *The Great Bathers*,
1887, Oil on canvas,
115 x 170 cm,
Philadelphia Museum
of Art, Philadelphia

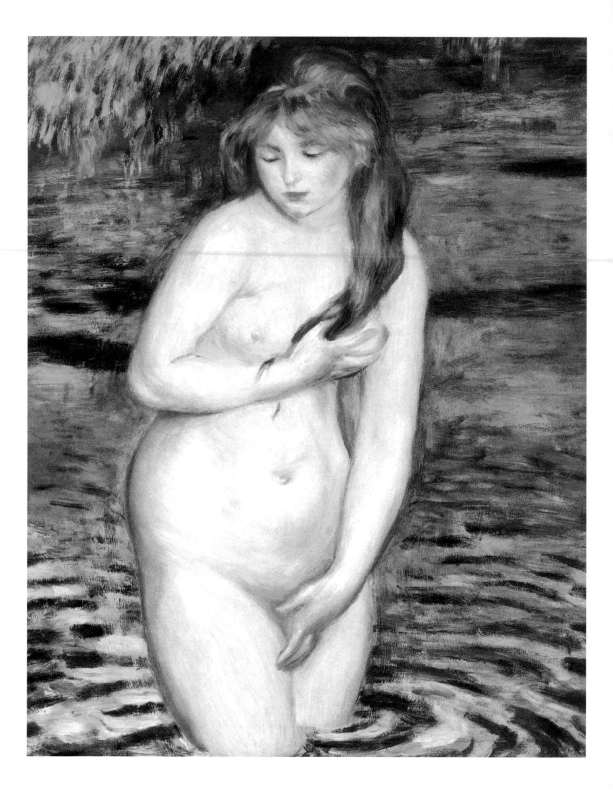

45. *Young Woman Bathing*, 1888,
Oil on canvas,
85 x 66 cm,
Private Collection

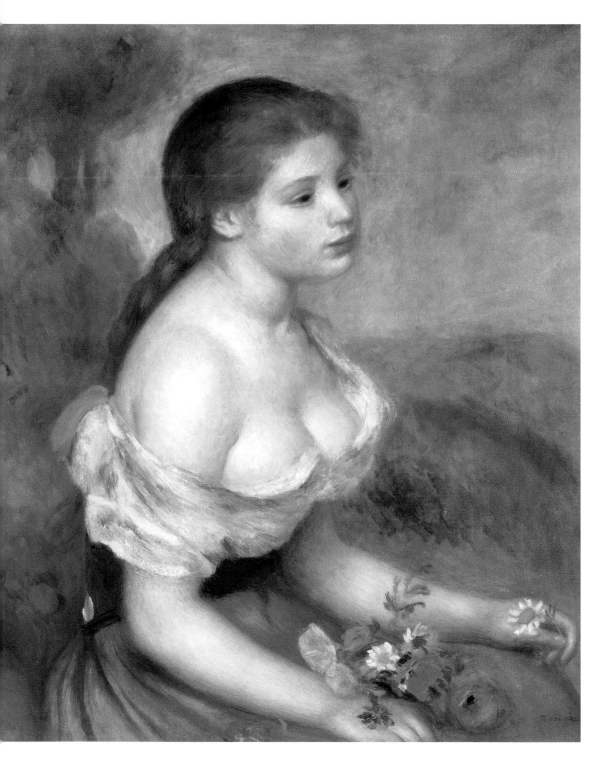

46. ***Young Girl with
 Daisies***, 1889,
 Oil on canvas,
 65.1 x 54 cm,
 The Metropolitan
 Museum of Art,
 New York

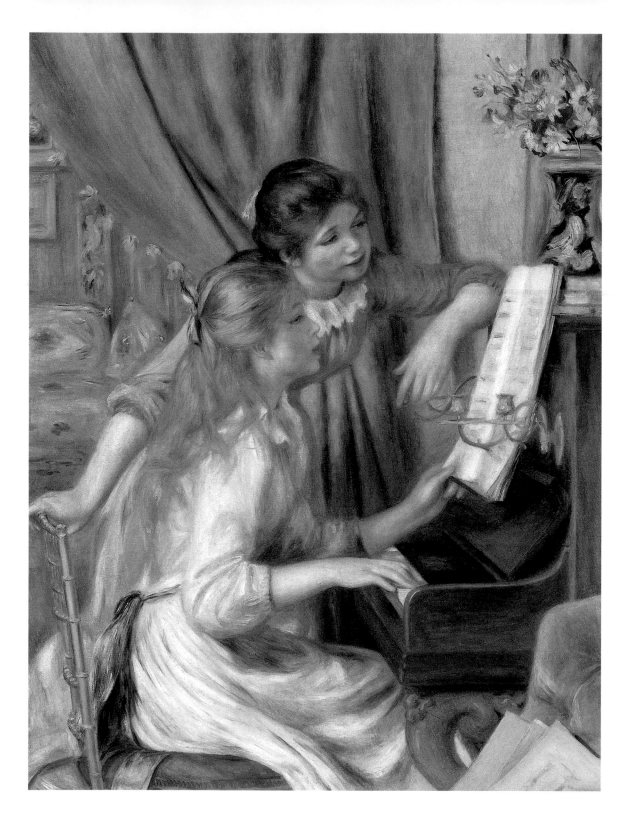

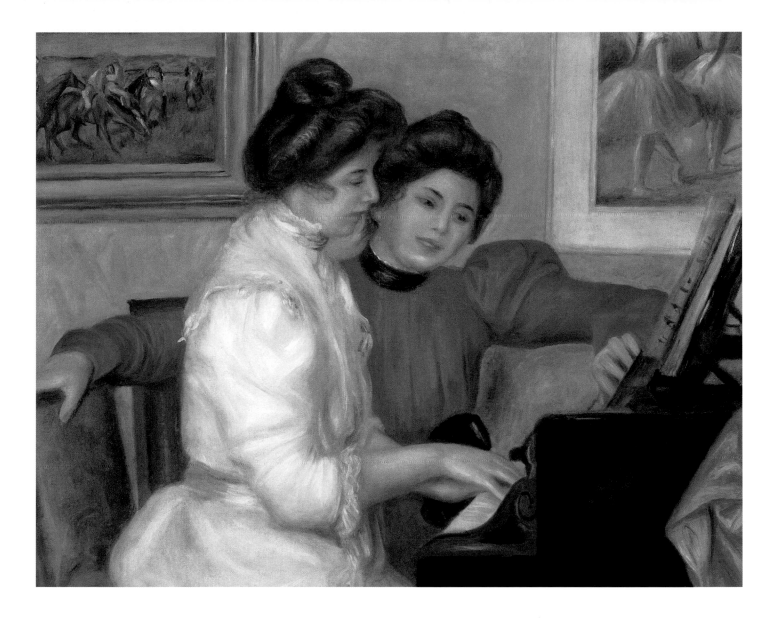

47. *Young Girls at the Piano*, 1892, Oil on canvas, 116 x 90 cm, Paris, Musée d'Orsay

48. *Yvonne and Chistine Lerolle at the Piano*, 1897, Oil on canvas, 73 x 92 cm, Paris, Musée de l'Orangerie

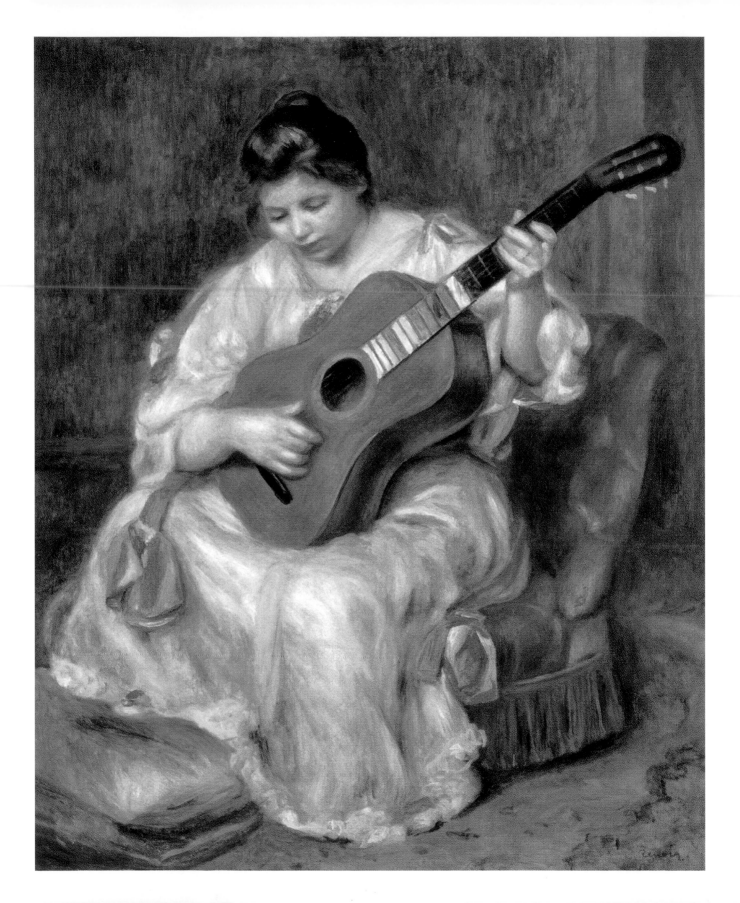

Renoir found the subject for this last work right by his house, on the Rue Cortot, in the restaurant called Le Moulin de la Galette. It is more of a motif than a subject: Renoir's canvases never did have a subject as such, since any kind of narrative or descriptiveness in painting was repugnant to him. "The most significant thing about our movement, I think, is that we liberated painting from the subject," he told Jean. "I can paint flowers and call them simply flowers without telling any story [17]".

As always he peopled the painting with close friends: on the right, at the table, we can identify Frank-Lamy, Gœneutte and Georges Rivière; among the dancers, Lestringuez and Paul Lhote. In the centre of the foreground are two sisters, Estelle and Jeanne, whom Renoir found in Montmartre (like, incidentally, almost all his models in this period). With the help of a little stratagem — introducing himself to the girls' parents — he persuaded them that it was safe to pose for him. It was in Montmartre too that he discovered Anna, who featured in many of his paintings; Angèle, who helped him to rent the garden with the swing that then appeared in *"The Swing"* (La Balançoire) and finally, Margot, whom we see for the first time in *"The Ball at the Moulin de la Galette"* (Le Bal du Moulin de la Galette), dancing with the tall Spaniard Don Pedro Vidal de Solares y Cardenas, another of the artist's acquaintances. Margot later posed for a whole number of paintings, including a painting accepted for the Salon in 1878 under the title *"The Coffee"* (Café). In 1879 she died of an illness which the doctors were unable to treat. This loss was a severe blow to Renoir.

In *"The Ball at the Moulin de la Galette"* (Le Bal du Moulin de la Galette), Renoir did more than create a picture of a scene familiar to the inhabitants of Montmartre. The mobility of his manner of painting, the vibration of patches of light and shade create an atmosphere of natural vitality. It is interesting that Georges Rivière, in an article for the newspaper *Impressionnisme*, approached this painting by his beloved Renoir from a rather unexpected point of view: "Monsieur Renoir can be justly proud of his *"Ball"*. Never has his inspiration been greater. It is a page of history, a precious monument of Parisian life possessing the strictest precision. No one before him ever thought to set down facts from everyday life on a canvas of such great size… It is a historical painting [18]".

At the Second Impressionist Exhibition (1876), Renoir mainly presented portraits, because that was the genre in which he was trying to earn his living. Friends introduced him to people who might commission works from him. The existing small circle of admirers of his art was joined by the financiers Henri Cernuschi and Charles Ephrussi, who began buying his paintings. Eugène Murer, the owner of a restaurant on the Boulevard Voltaire, asked Renoir and Pissarro to paint the interior of the dining-room there. Every Wednesday he fed a whole company of artists free of charge.

49. *Young Woman Playing the Guitar*, 1896-1897, Oil on canvas, 81 x 61 cm, Lyon, Musée des Beaux-Arts

Eventually, he also commissioned portraits, of himself and his sister, from Renoir. In 1879, Renoir met the diplomat Paul Bérard, who became another friend and patron. In 1877, at the Third Impressionist Exhibition, Renoir presented a whole panorama of over twenty works of painting. They included landscapes created in Paris, on the Seine, outside the city and in Claude Monet's garden; studies of women's heads and bouquets of flowers; portraits of Sisley, the actress Jeanne Samary, the writer Alphonse Daudet and the politician Spuller; and also "The Swing" and "The Ball at the Moulin de la Galette". The labels on some of the paintings indicated that they were already the property of Georges Charpentier. The artist's friendship with the Charpentier family was to play a significant role in shaping his destiny.

Madame Charpentier's salon was frequented by writers, actors, artists and politicians. Besides Maupassant, Zola, the Goncourts and Daudet, whom Georges Charpentier published, it was even possible to come across Victor Hugo and Ivan Turgenev there. Renoir was a constant caller at the house.

At the Seventh Impressionist Exhibition, held in 1882, Renoir was again represented with twenty-five works, but that was on the initiative of Paul Durand-Ruel, who made the paintings that he owned available.

By 1882, Renoir really did have good cause to fear losing the success that he had achieved in the Salon. Now he had a wife to support. The story began a little earlier, in about 1880. At that time Renoir's paintings and drawings increasingly featured the face of a young girl with round cheeks and a short, slightly turned up nose. Sometimes we get a glimpse of this face in the crowd on the Place Pigalle, leaving behind it a sense of fleeting happiness. Sometimes we detect its presence in the image of a red-headed girl reading, sometimes in the lissom figure of a girl taking her seat in a boat. Then finally, in the 1881 painting "The Luncheon of the Boating Party" (Le Déjeuner des canotiers), a portrait of her appears: she is depicted in the bottom left-hand corner of the canvas, in a fanciful, fashionable hat, holding a Pekinese in her hands. Her name was Aline Charigot and in 1880 she was twenty-one years old. Renoir met her in Madame Camille's dairy shop on the Rue Saint-Georges. She lived close by with her mother and earned her living by dressmaking. The owner of the shop had hopes of marrying one of her own daughters to the artist, but fate decided otherwise. The mutual attraction between Renoir and Aline was impossible to overlook. Jean Renoir hit on a profound truth when he stated that his father began depicting his mother long before the two met. It really is the case that in many earlier paintings, such as "The First Outing" (Première sortie) of 1876, the model already resembles Aline. Renoir had already turned forty but now his youth seemed to return to him.

50. *The Sleeper*, 1897, Oil on canvas, 82 x 66 cm, Winterthur, Oskar Reinhart "Am Römerholz" Collection

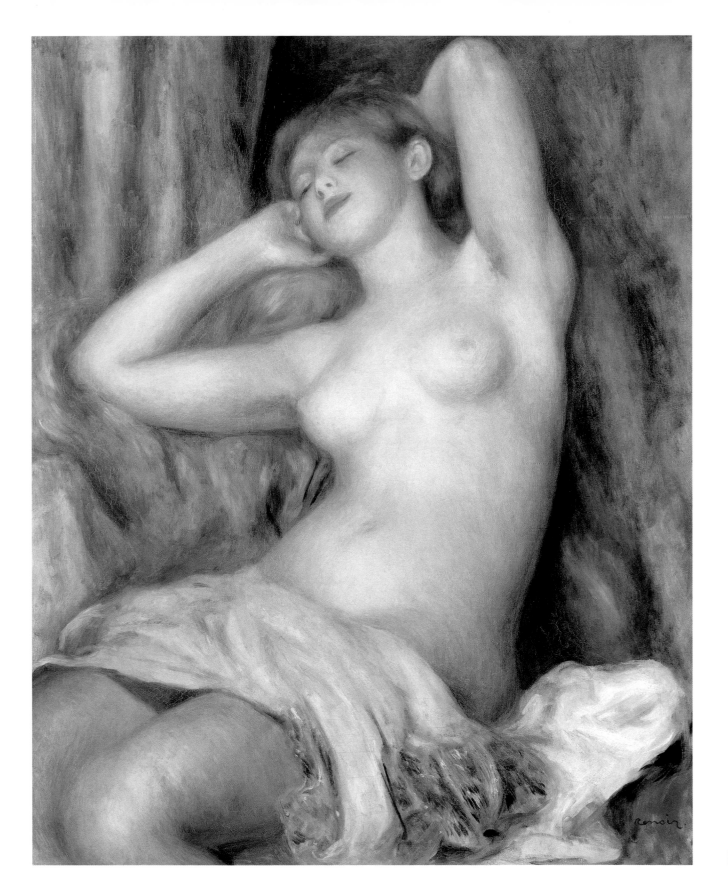

In the period 1881–1882 Renoir moved about many times from place to place, perpetuating them in his work mainly in the form of landscapes. He continued to paint on the Seine, at Chatou and Bougival, his habit of working in those places was so dear to him that he turned down the critic Théodore Duret's invitation to make a trip to England. "The weather's set fair and I have got models. That is my only excuse [19]". Perhaps the true reason was Aline — Renoir was just on the point of finishing *"The Luncheon of the Boating Party "*. Yet in that same year, 1881, Renoir (together with his friend Cordey) visited Algeria for the first time, bringing back *"Banana Plantation and Arab Holiday"* (Champ de bananiers et la fête arabe). After a short stay in Dieppe, he set off for Italy. He travelled through Milan, Venice and Florence. After that, Renoir returned to the south of France, where he worked together with Cézanne. In Estaque he fell ill with influenza and pneumonia and in March 1882 he again headed for Algeria. "Dear Monsieur Durand-Ruel," he wrote from there, "I have installed myself close to Algiers itself and am conducting negotiations with the Arabs in search of models [20]".

In May 1882, Renoir returned to Paris, with Aline still on his mind. That moment was in effect the start of a new life for Renoir. Money was needed to support a wife. Fortunately the artist's efforts and stubborn work had not been in vain: now he was receiving commissions for portraits. Among his patrons was his old friend Paul Durand-Ruel. Renoir painted portraits of his five children and three panels depicting a dance as well as doing a wall painting in his house. In 1883 Durand-Ruel organized Renoir's first one-man show on the Boulevard de la Madeleine. It included seventy paintings. Although Durand-Ruel was not always successful in his attempts to sell the Impressionists' paintings, he decided to open another gallery in New York. Finally, in the 1880s Renoir hit a "winning streak". He was commissioned by rich financiers, the owner of the Grands Magasins du Louvre and Senator Goujon. His paintings were exhibited in London and Brussels, as well as at the Seventh International Exhibition held at Georges Petit's in Paris in 1886. In a letter to Durand-Ruel, then in New York, Renoir wrote: "The Petit exhibition has opened and is not doing badly, so they say. After all, it's so hard to judge about yourself. I think I have managed to take a step forward towards public respect. A small step, but even that is something [21]". Renoir was never inclined to overestimate himself. In the 1880s Renoir travelled extensively. He often painted in the towns and on the beaches of Normandy. He visited the Channel Islands of Guernsey and Jersey with Aline and Paul Lhote. In the winter of 1883 Renoir travelled around the Riviera with Claude Monet. In March 1885 Renoir's first son, Pierre, was born. To pay the doctor who attended at the birth, Renoir painted the walls of his apartment with flowers — the dream of decorative works was still not extinct, but after the artist's journeys to Italy it had acquired a nostalgic quality.

51. *Portrait of Miss Misia Edwards* (*Misia Sert*), 1907, Oil on canvas, 92 x 73.5 cm, Merion (PA), The Barnes Foundation

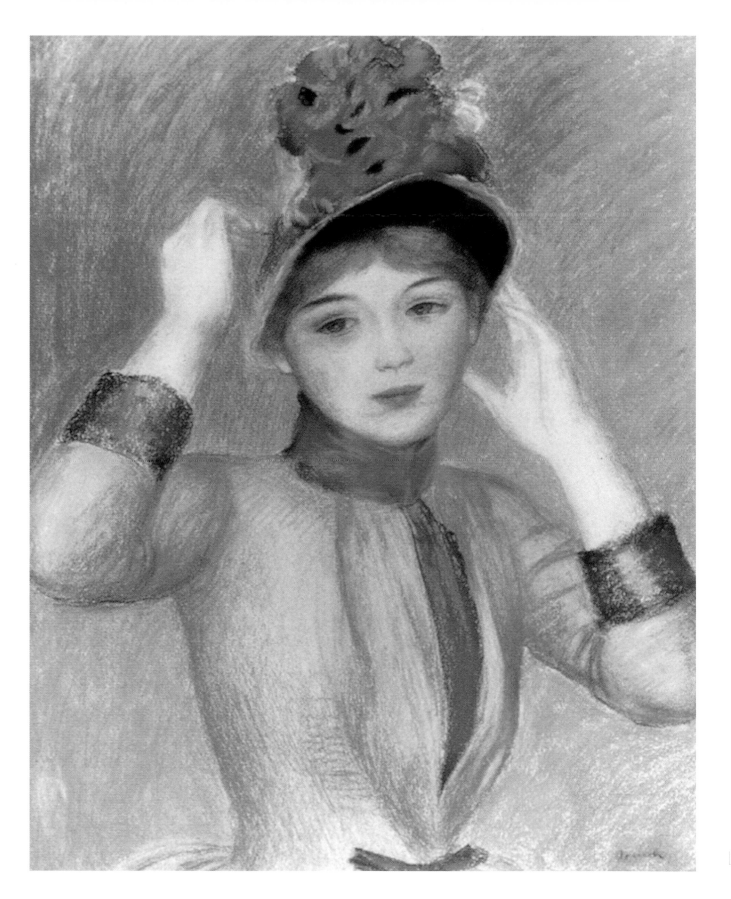

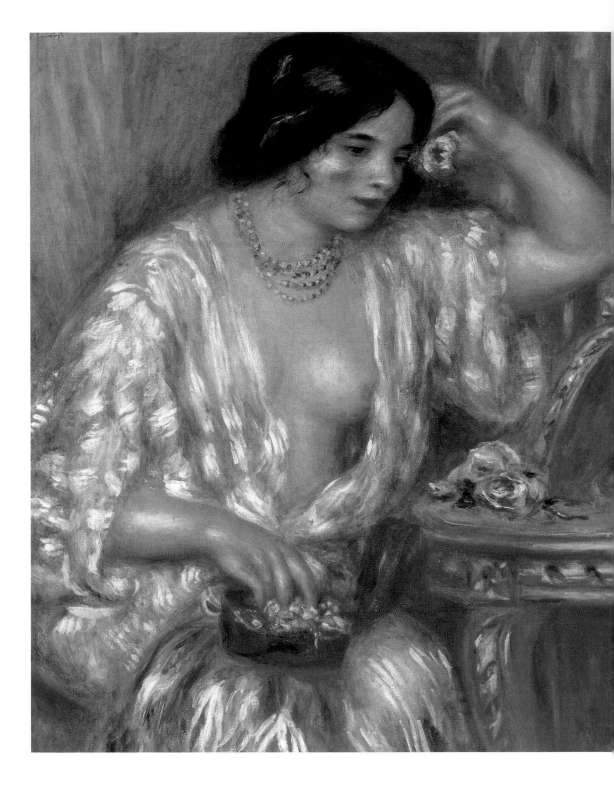

52. *Gabrielle with Jewels*, ca. 1910,
Oil on canvas,
81 x 65 cm, Geneva,
Private Collection

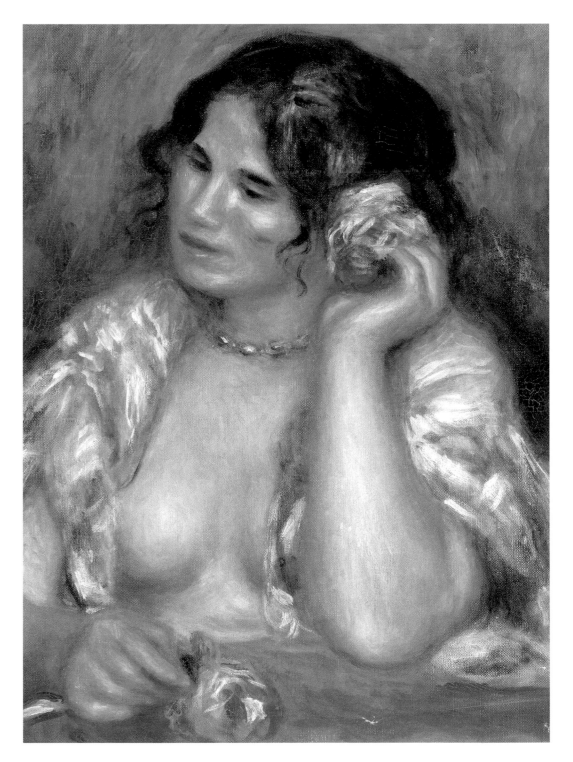

53. *Gabrielle with the Rose*, 1911, Oil on canvas, 55 x 47 cm, Paris, Musée d'Orsay

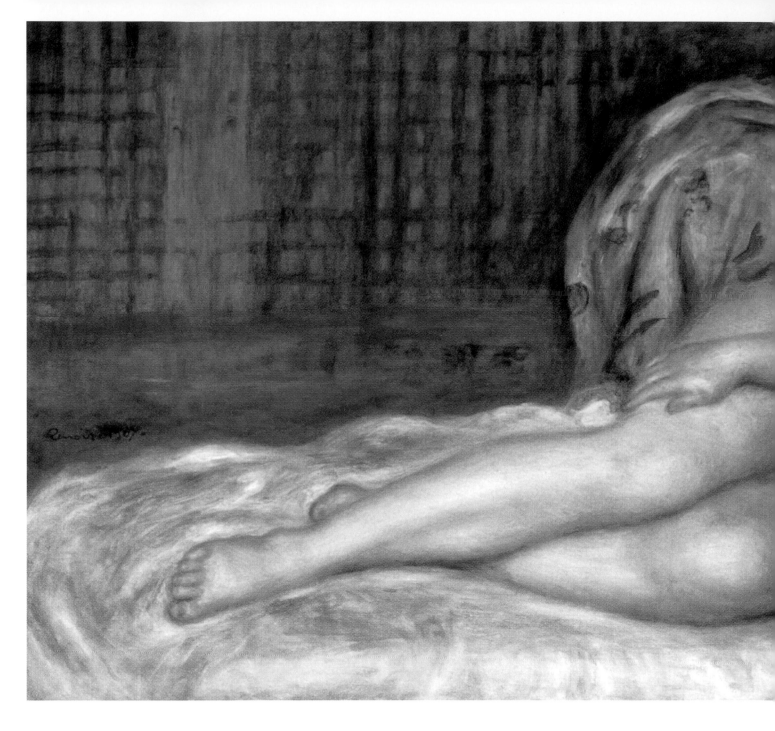

54. *Nude on Cushions*,
 1907, Oil on canvas,
 70 x 155 cm, Paris,
 Musée d'Orsay

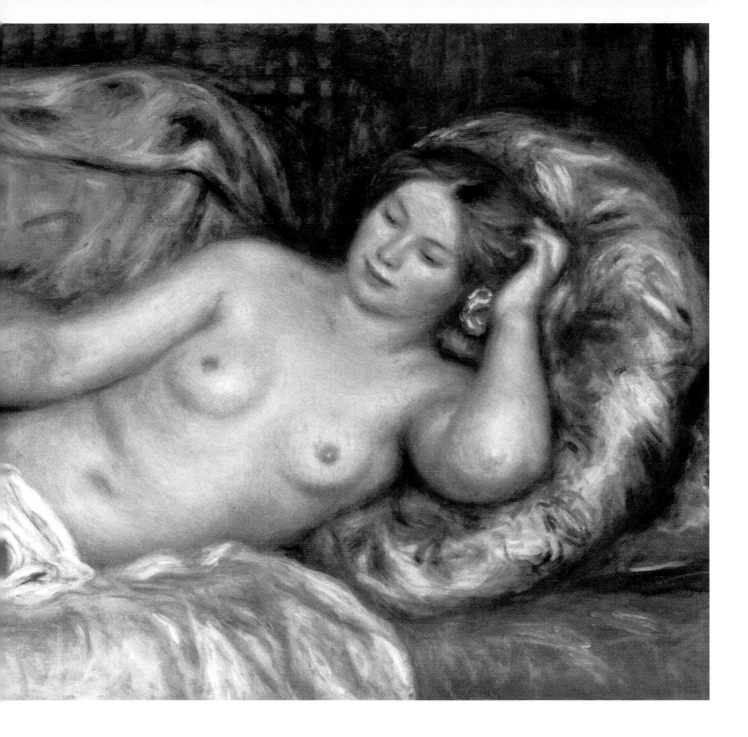

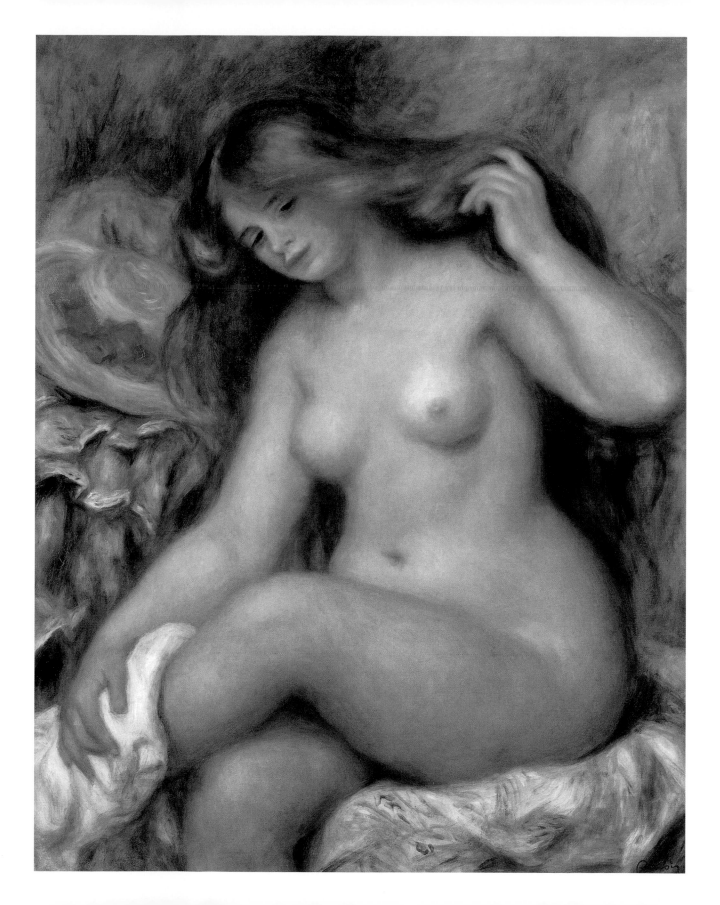

In the autumn the Renoirs travelled to Aline's native village, Essoyes in Champagne. The artist frequently made sketches of is wife feeding their child. A year later he used these sketches to produce the painting "Maternity" (Maternité).

In Renoir's creative life the 1880s were not so serene. In discussions with Ambroise Vollard he was talking about the sense of an impasse which had come upon him perhaps as early as 1883. Dissatisfaction with the former, Impressionistic manner of painting prompted the artist to search for something new, looking, as before, even further back in Classical art. It seemed to him that he did not know how to paint or to draw. In a state of depression, he destroyed a whole group of finished works. At this difficult moment, it was Ingres who came to Renoir's assistance — that very Ingres who had been scorned by Renoir's circle during his youth. In Renoir's artistic biography, the 1880s are customarily called the Ingres period. A tendency to stricter draughtsmanship, precise line and clear form, and even to a greater use of local colour can be traced in all the paintings of that time. To some extent they can already be detected in "Luncheon", and more so in "Maternity" and "The Umbrellas" (Les Parapluies). This last work, painted in two stages — started in 1881 and completed in 1885 — is astonishing evidence of the way in which the artist's manner of painting evolved. It is fairly soft and Impressionistic on the right-hand side, it is far tougher and more laconic on the left. In Normandy in 1884, Renoir painted a portrait of Paul Bérard's three daughters: "The Children's Afternoon at Wargemont " (L' Après-midi des enfants à Wargemont). Apart from the Ingres-like purity of line and form, this large painting also has one quality unique to Renoir's way of working in this period. Its pink and pale blue palette calls to mind the painting of the Rococo, of the eighteenth century which figured largely in Renoir's dreams. "I have again taken up the old soft and light manner of painting, so as not to be unfaithful to it any more," he wrote to Durand-Ruel from Essoyes in the autumn of 1885. "… There is nothing new in this, but it is a direct continuation of the works of the eighteenth century [22]". He was thinking specifically of Fragonard and Watteau, whose works he had loved since childhood, since the time when his greatest dream was to paint porcelain at the Sèvres factory. In 1885, Renoir painted the large composition "In the Garden. Under the Trees" (Dans le jardin), which became a kind of farewell from him to the "perpetual holiday" of La Grenouillère and the Moulin de la Galette. The quivering of touch, the vibration of light and shade were left behind. In Renoir's new painting everything was calm and stable. The bright light intensifies the green of the leaves and the reflexes from the bouquet of flowers on the yellow straw hat. Again his model resembles Aline, but now it is already that new Aline who embodies the peace of his family life. The Renoir family were constant visitors to the village of Essoyes.

55. *The Bather*, ca. 1909,
Oil on canvas,
92.7 x 73.4 cm,
Vienna,
Österreichische
Belvedere Gallery

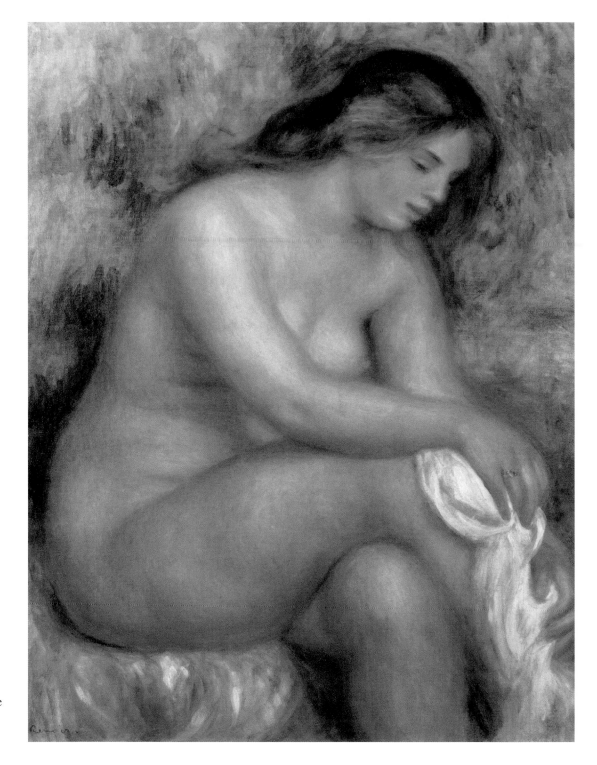

56. *The Bather Wiping her Leg*, ca. 1910, Oil on canvas, 84 x 65 cm, São Paulo, Museu de Arte de São Paulo, Assis Chateaubriand

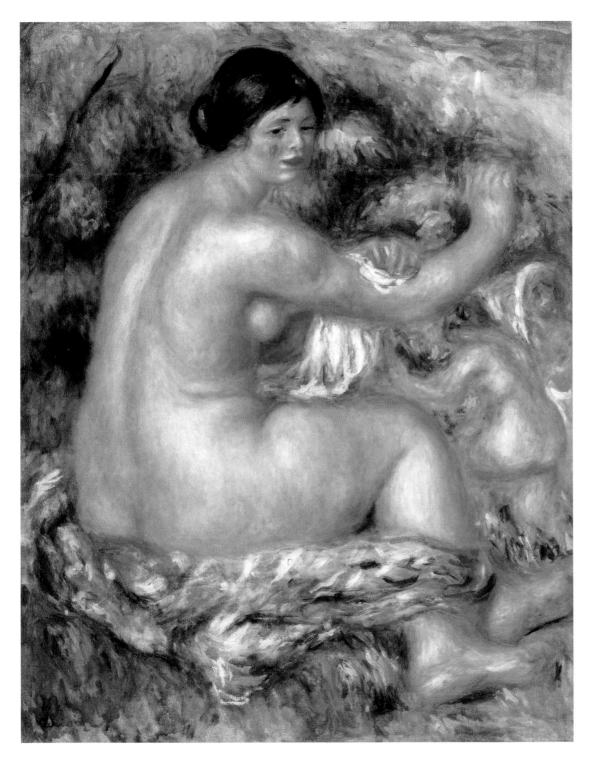

57. *After the Bath*, 1912,
Oil on canvas,
67 x 25.5 cm,
Winterthur,
Kunstmuseum

On 14 April 1890, Auguste Renoir officially registered his marriage to Aline Charigot in the *mairie* of the 9th arrondissement. It was here, in 1894, that the future film-director was born, the second son of Auguste and Aline Renoir. Vollard became Renoir's dealer, friend and biographer. The dark-haired "gypsy" in the garden was Gabrielle Renard, a cousin of Aline's, who had been summoned from Essoyes to help in the household. By the time she came, Pierre was already quite big and Jean became her main concern. Montmartre grew used to seeing Gabrielle carrying the younger Renoir boy on her back. Later Gabrielle became one of the elderly Renoir's favourite models. Among the other friends Berthe Morisot "bequeathed" to Renoir was the writer Stéphane Mallarmé. Thadée Natanson, publisher of the Symbolist journal *La Revue Blanche*, left us a vivid description of Renoir in 1896: " Constant excitement speeds Renoir's gait, bends and straightens his back, forces his deformed fingers to move, renders nervous the constant motion of his lean body, on which his fluttering clothing hangs in folds... His face is furrowed, etched with wrinkles, drawn, wizened, rough with grey bristles. It has protruding cheekbones and glittering eyes that contain a glow, and a tenderness at the same time. His agile fingers are constantly plucking and smoothing his grey moustache and beard... He paces back and forth. He sits down, gets up and, having just got up, decides to sit down again, to get up again (...) he makes up for that silence by his rapid speech — he always finds a way to talk with renewed passion about the art of painting. In passing, he laughs at a joke, amuses himself with an anecdote, points out something funny, gets indignant or starts protesting, then comes back to the artists of the eighteenth century [23]". Renoir's health was never strong. Reading through his letters, you continually come across references to bronchitis and pneumonia, which kept him in bed for long periods at a time. A bout of neuralgia at Essoyes in 1888 left him with one side of his face paralysed, and in 1897 he suffered a real misfortune. On a rainy summer's day at Essoyes he fell off a bicycle and broke his right arm. Fortunately, he had already taught himself to paint with his left following a previous fracture and his work was not interrupted. Aline cleaned his palette, washed the brushes and scraped the paint from unsatisfactory parts of the canvas. Nevertheless, this last fall proved a fateful occurrence. The artist began to be troubled by pain and the Renoirs' family doctor did not console him with his accounts of the incurable kinds of arthritis brought on by such injuries. Renoir was condemned to spend the last twenty years of his life in constant suffering, aware that he was threatened with complete immobility that would mean an end to his work. Yet his fragile body contained a fantastic will to live and a passion to create. He kept working until the last.

Those last twenty years, most of them belonging to a new century, also brought great joys.

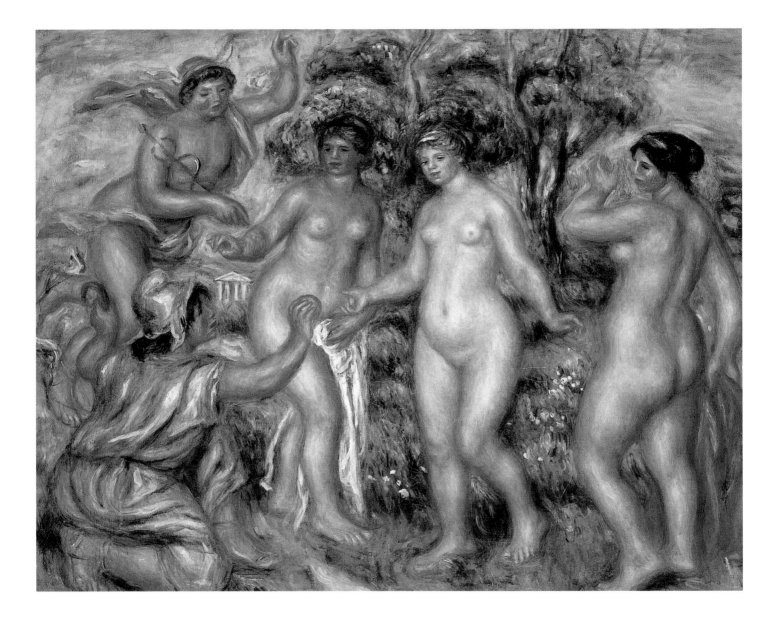

58. ***The Judgment of
Pâris***, 1914, Oil on
canvas, 73 x 92.5,
Hiroshima, Hiroshima
Museum of Art

In 1901, Aline gave Renoir a third son, Claude, who replaced the growing Jean as a model. In 1900 Renoir was made a chevalier of the Legion of Honour, and in 1911 an officer. A whole series of exhibitions were held in Paris, New York and London, turning into a real triumph for Renoir. The artist was especially delighted by a retrospective showing of his painting at the Second Salon d'Automne in 1904, where he was accorded an entire hall. He displayed his work there alongside the young artists — Bonnard, Vuillard, Valtat, Roussel and Matisse — who not only had become his successors in painting, but also surrounded him during the final years of his life.

Renoir wrote to Durand-Ruel in the October of 1904: "I agreed because I trusted the organizers of the exhibition. I am delighted at what I did. Everybody is happy. Those whom I managed to see think that the exhibition is most interesting and, what is quite rare, organized with taste. It's a success [24]".

In this period the family lived by turns in Paris, on the Boulevard Rochechouart; on the Mediterranean coast; and in little villages in the south of France, trying to find the place with the climate that suited Renoir best.

Finally, they came to rest in the village of Cagnes.

Gabrielle posed for him as did other models who became almost members of the family and stayed on to live in the house. They were given nicknames — la Boulangère, la Grand-Louise. One of the last models was a red-head called Andrée, who after the artist's death became Jean's wife.

The main idea running through the last years of Renoir's work was the creation of a large painting with nude figures, coming close to a wall-painting. As far back as 1887 he had painted *"The Great bathers"* (*Les Grandes baigneuses*) in the somewhat austere Ingres-inspired manner of those years. With time his thoughts returned ever more often to the decorative works of the great Italian painters.

In 1914 the Great War began and the artist's two elder sons went off to the front. This event proved too much for Aline — she died within the year, leaving Renoir alone. Pierre and Jean came back wounded, but life, nonetheless, settled back into an established pattern. Renoir continued to work, but every day it became harder. The rheumatism eventually crippled him, but he never ceased to paint. When his fingers were no longer supple, he continued by binding his paintbrush to his hand.

He died of pneumonia at Les Collettes on 2 December 1919, after managing to finish his last work, a still life with anemones. He had lived a long life. At the beginning of the twentieth century he had seen the appearance of kinds of painting which the Impressionists could not even have imagined in their youth — Matisse and his fellow Fauves, Picasso and his Cubism. And all his life he remained the way he had always been.

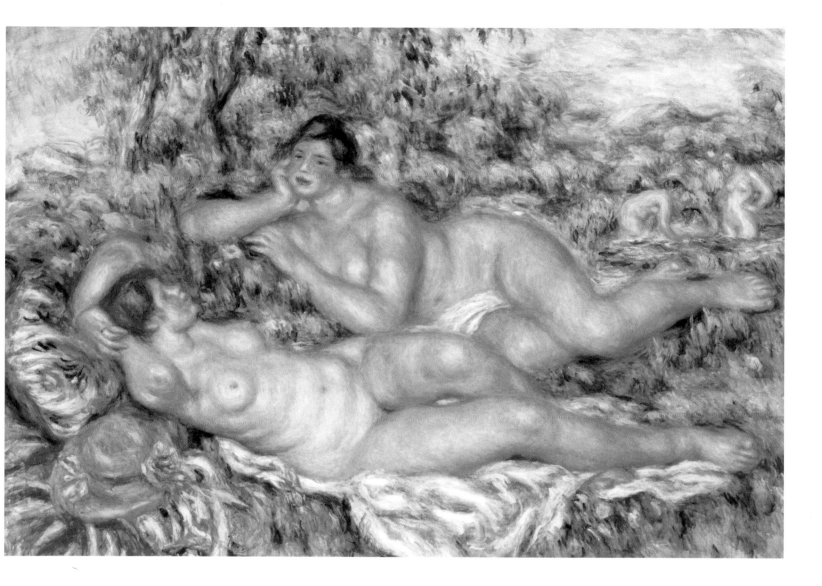

59. *The Bathers*,
1918-1919,
Oil on canvas,
110 x 160 cm, Paris,
Musée d'Orsay

LIST OF ILLUSTRATIONS

1. Self-Portrait, ca. 1875. p.4
2. Jules Le Cœur Walking in the Fontainebleau Forest with his Dogs, 1866. p.7
3. La Grenouillère, 1869. p.8
4. At the Inn of Mother Anthony, 1866. p.9
5. Alfred Sisley and his Wife, 1868. p.10
6. Lisa (Woman with a Parasol), 1867. p.11
7. Odalisque (Woman of Algiers), 1870. p.12
8. Interior of a Harem in Montmartre, 1872. p.14
9. Bather with a Griffon. p.15
10. The Algerian, 1870. p.16
11. Diane the Huntress, 1867. p.17
12. The Promenade, 1870. p.18
13. Half-naked Woman Lying Down: the Rose, ca. 1872. p.19
14. Riders in the Bois de Boulogne, 1873. p.20
15. The Parisienne (Henriette Heriot), 1874. p.21
16. The Box, 1874. p.22
17. Nude in the Sun, 1875. p.23
18. The Lovers, ca. 1875. p.24
19. Garden in the Rue Cortot, Montmartre, 1876. p.25
20. In the Garden, La Tonnelle. p.26
21. The Swing, 1876. p.27
22. The Ball at the Moulin de la Galette, 1876. p.28
23. Lady in Black, ca. 1876. p.29
24. The Reading of the Part, 1874-1876. p.30
25. Young Woman Sewing, ca. 1879. p.31
26. The Thought, ca. 1876-1877. p.34
27. Woman with Cat, ca. 1875. p.35
28. The Nude, 1876. p.36
29. The First Outing, ca. 1876. p.37
30. The First Step, 1876. p.39
31. Jeanne Samary, 1877. p.40
32. Portrait of the actress Jeanne Samary, 1878. p.41
33. The Exit of the Conservatory, 1877. p.42
34. La Place Clichy, ca. 1880. p.43
35. Young Girl with a Cat, 1880. p.45
36. The Lunch of the Boaters, 1880-1881. p.46
37. Blond Bather, 1881. p.48
38. The Umbrellas (After the Rainfall), ca. 1881-1885. p.49
39. Miss Marie-Therese Durand-Ruel Sewing, 1882. p.50
40. A Woman's Bust, Yellow Corsage, ca. 1883. p.51
41. La Coiffeuse (Bather Arranging her Hair), 1885. p.52
42. Maternity – The Child Breastfed, 1886. p.53
43. The Braid (Suzanne Valadon), 1884-1886. p.54
44. The Great Bathers, 1887. p.56
45. Young Woman Bathing, 1888. p.58
46. Young Girl with Daisies, 1889. p.59
47. Young Girls at the Piano, 1892. p.60
48. Yvonne and Chistine Lerolle at the Piano, 1897. p.61
49. Young Woman Playing the Guitar, 1896-1897. p.62
50. The Sleeper, 1897. p.65
51. Portrait of Miss Misia Edwards (Misia Sert), 1907. p.67
52. Gabrielle with Jewels, ca. 1910,. p.68
53. Gabrielle with the Rose, 1911. p.69
54. Nude on Cushions, 1907. p.70
55. The Bather, ca. 1909. p.72
56. The Bather wiping her leg, ca. 1910. p.73
57. After the Bath, 1912. p.74
58. The Judgment of Pâris, 1914. p.77
59. The Bathers, 1918-1919. p.79

NOTES

[1] L.Venturi, *Les Archives de l'impressionnisme. Lettres de Renoir, Monet, Pissaro, Sisley et autres. Mémoires de Paul Durand-Ruel. Documents*, Paris- New York, 1939, t. II, p. 335

[2] Jean Renoir, Pierre-Auguste Renoir, mon père, Paris, 1981, p. 18

[3] Albert André, *Renoir*, Paris, 1919, p.33

[4] J.Renoir, *Pierre-Auguste Renoir, mon père*, Paris, 1981, p.115

[5] J.Renoir, *Pierre-Auguste Renoir, mon père*, Paris, 1981, p.115

[6] J.Renoir, *Pierre-Auguste Renoir, mon père*, Paris, 1981, p.117

[7] Albert André, *Renoir*, Paris, 1919, p.34

[8] Albert André, *Renoir*, Paris, 1919, p.36

[9] J.Renoir, *Pierre-Auguste Renoir, mon père*, Paris, 1981, p.113

[10] J.Renoir, *Pierre-Auguste Renoir, mon père*, Paris, 1981, p.227

[11] J.Renoir, *Pierre-Auguste Renoir, mon père*, Paris, 1981, p.225

[12] L.Venturi, *Les Archives de l'impressionnisme. Lettres de Renoir, Monet, Pissaro, Sisley et autres. Mémoires de Paul Durand-Ruel. Documents*, Paris- New York, 1939, t. II, p 340

[13] J.Renoir, *Pierre-Auguste Renoir, mon père*, Paris, 1981, p.172

[14] L.Venturi, *Les Archives de l'impressionnisme. Lettres de Renoir, Monet, Pissaro, Sisley et autres. Mémoires de Paul Durand-Ruel. Documents*, Paris- New York, 1939, t. II, p 289

[15] L.Venturi, *Les Archives de l'impressionnisme. Lettres de Renoir, Monet, Pissaro, Sisley et autres. Mémoires de Paul Durand-Ruel. Documents*, Paris- New York, 1939, t. II, p 283

[16] J.Renoir, p.207

[17] J.Renoir, p.199

[18] L.Venturi, *Les Archives de l'impressionnisme. Lettres de Renoir, Monet, Pissaro, Sisley et autres. Mémoires de Paul Durand-Ruel. Documents*, Paris- New York, 1939, t. II, p 309

[19] François Daulte, *Auguste Renoir. Figures (1860s– 1890)*, Lausanne, 1971, p.45

[20] L.Venturi, Les Archives de l'impressionnisme. Lettres de Renoir, Monet, Pissaro, Sisley et autres. Mémoires de Paul Durand-Ruel. Documents, Paris- New York, 1939, t. I, p.124

[21] L.Venturi, *Les Archives de l'impressionnisme. Lettres de Renoir, Monet, Pissaro, Sisley et autres. Mémoires de Paul Durand-Ruel. Documents*, Paris- New York, 1939, t. I, p.138

[22] L.Venturi, Les Archives de l'impressionnisme. Lettres de Renoir, Monet, Pissaro, Sisley et autres. Mémoires de Paul Durand-Ruel. Documents, Paris- New York, 1939, t. I, p.131

[23] *La Revue Blanche*, n°73, Paris, June 15th 1896, p.554

[24] *Les Archives de l'impressionnisme*, T.I, p.184